A GUIDE
TO HISTORIC
Plymouth

A GUIDE
TO HISTORIC
Plymouth

JAMES BAKER

THE
History
PRESS

Published by The History Press
Charleston, SC 29403
www.historypress.net

Cover image: Detail from *The First Thanksgiving at Plymouth*, 1914, by Jennie Augusta
Brownscombe. *Courtesy of Pilgrim Hall Museum, Plymouth, Massachusetts.*

All images are from the collection of the author or Pilgrim Hall Museum.

First published 2008
Second printing 2013

Manufactured in the United States

ISBN 978.1.59629.228.4

Library of Congress Cataloging-in-Publication Data

Baker, James W.
A guide to historic Plymouth / James Baker.
p. cm.
Includes bibliographical references.
ISBN 978-1-59629-228-4 (alk. paper)
1. Plymouth (Mass.)--Guidebooks. 2. Plymouth (Mass.)--Tours--Guidebooks.
I. Title.
F74.P8B35 2007
917.44'82--dc22
2007041974

Contents

Plymouth's Pilgrim Origins

The history of Plymouth, Massachusetts, famously begins on the other side of the Atlantic in England where the counties of Nottinghamshire, Yorkshire and Lincolnshire meet. At the beginning of the seventeenth century, religious dissidents there established covenantal congregations in defiance of the national church and of King James I, its supreme head. These Separatists, under the leadership of Richard Clifton, John Smyth, William Brewster and John Robinson, were convinced that a true Christian could not continue to worship in a church that did not follow scripture in its administration and mingled godly people with the profane. They chose to withdraw and form their own churches after the model they found in the New Testament. At a time when church and state were one, this was both heresy and sedition. They knew it put them in terrible danger.

Earlier separatists (not necessarily Congregationalists) had been burned at the stake in Queen Mary's time. In 1593 three Cambridge scholars, John Penry (a contemporary of William Brewster's at Peterhouse College), John Greenwood and Henry Barrow, were hanged in Southwark (across the Thames from London) for embracing Separatism. Other Separatists, such as Robert Browne, Francis Johnson and Henry Jacob, had fled to the Netherlands to escape a similar fate.

The traditional date for the establishment of the Pilgrim church is 1606. The first pastor was Richard Clifton, who had been rector at All Saints in Babworth (Nottinghamshire) until he was deprived in March 1605. John Robinson, a minister born in nearby Sturton-le-Steeple, had resigned his living at St. Andrew's in Norwich a few months earlier and was second in command. William Brewster, a well-educated man who had left Cambridge without a degree, provided a refuge for worship at Scrooby Manor, where he was employed as bailiff and postmaster. John Smyth was a pastor of a related separatist community in neighboring Gainsborough, over the county border in Lincolnshire. Among others who joined the Separatists was a young man from Austerfield—a few miles to the north in Yorkshire—named William Bradford.

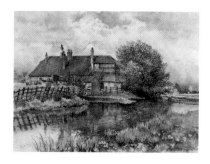

Scrooby Manor—watercolor by Elizabeth M. Chettle, 1907. The old brick farmhouse shown here is all that survives of Scrooby Manor where Elder William Brewster lived and hosted the beginnings of the Leiden Separatist congregation.

The Separatists' absence from their parish churches brought them to the notice of the Church Courts, whose inquiries carried legal sanctions and fines. The congregation decided to leave the country and follow earlier religious refugees to Holland, where a climate of tolerance, unique for the time, existed. The first attempt to escape was made at Fishtoft near Boston, England, in 1607. They hired a ship to secretly meet them at a secluded spot on the River Witham and transport them and their belongings across the North Sea. Once the refugees and their goods were aboard the ship, however, they discovered that the shipmaster had betrayed them to the authorities. They were arrested, roughly searched, their belongings confiscated and they were marched up to the Boston jail. Brought before the local magistrates (who treated them as well as possible, given the circumstances), they were confined for a month before orders from a higher court allowed all but seven principal men to return to their original villages. The seven were brought before the Assize Courts and probably fined before being released.

Another mass attempt to flee England was made the following spring in 1608. A Dutch shipmaster agreed to take them across to Holland, and another rendezvous was arranged. This time the Separatists divided into two parties. The men went on foot overland to a meeting spot on the coast "between Grimsby and Hull." The women, children and their baggage were carried by boat up the River Trent and along the Humber estuary. However, the boat went aground on arrival and the passengers could not get off until the tide came in. When the Dutch ship appeared, the men went aboard to wait for the others. Before they could be reunited, an armed group of men was seen approaching. Fearing arrest, the Dutch shipmaster sailed away, leaving the boat's passengers and a few men still ashore to face the approaching posse. The English on the Dutch vessel were distraught. Unable to help their friends and families and having nothing but the clothes on their backs, they watched the others once again being arrested. It was worse than the previous time, for the Separatists had no place to go, having disposed of their homes, and no way to earn a living. Passed from one local authority to another, and living on charity until everyone wanted to be rid of them, they eventually made their way to Holland to join the men from the Dutch vessel.

Those on the Dutch ship had their own ordeal. After two weeks of terrible North Sea storms off the coast of Norway, in which the

sailors despaired of their lives and the English put their trust in God, the battered vessel finally limped into Amsterdam harbor. Thankful to be back on land again, they were aided by the "Ancient Brethren," an existing English Separatist church in Amsterdam. Soon after the stragglers from England began to arrive, the community gathered together again. However, it was not long before they were on the move once more. The English dissenters in Amsterdam were beset by quarrels and disputes, and John Smyth soon took his congregation to new extremes of religious radicalism. Although Rev. Clifton chose to remain with the Ancient Brethren, Robinson and Brewster decided to seek a more peaceful and promising home in the city of Leiden, about twenty-three miles southwest of Amsterdam. In January 1609, they wrote to Leiden city officials to obtain authorization to settle there, and received permission a month later. Brewster had been in Leiden while he was in Queen Elizabeth's diplomatic service under Sir William Davison in 1586, and Dr. Jeremy Bangs discovered that he had met the official that wrote the favorable reply, Jan van Hout, at that time. In May, John Robinson's congregation moved to Leiden.

The little group of Separatists found places to live and work in Leiden. Other English dissenters joined them, and over the next dozen years, the congregation grew to about three hundred persons. Reverend Robinson became highly regarded by the Dutch, and the whole community was respected. However, their new home was not entirely satisfactory. Some purchased homes and became prosperous citizens, but many were less fortunate and barely scraped by, in the manner of immigrants in every age. While they were indeed free to worship as they saw fit, economic and social pressures made life hard for old and young alike. Governor Bradford later listed their anxieties and discontents. It was particularly important to them that their community grow and attract other English people. They had a great ambition to spread the truth they had found, and did so by printing illegal religious books and serving as an example of a true Christian community. Unfortunately, precarious economic conditions

Leiden—engraving by W.H. Bartlett (1809–1854), 1853. The Pilgrims moved from Amsterdam to Leiden in 1609, after receiving permission from the Leiden city fathers to settle there.

turned would-be converts off. Similarly, death and hardship took their toll among those who were already in Leiden, which threatened the survival of the separatist community. Elderly people, worn out by menial work and with no resources, suffered. Even worse, young people were growing old before their time through oppressive labor, or leaving their community for an easier life among the Dutch as soldiers or sailors.

Beyond these immediate problems was the imminent threat of war. They had arrived in Holland just as a twelve-year truce began between the Protestant Dutch and their former ruler, Catholic Spain. The Spanish Hapsburgs had governed the Dutch provinces until Protestant resistance brought bloody and prolonged war to the region. The northern provinces had been able to hold off the Spanish armies and the two sides agreed on a peace that was to last until 1621. When this lull was over, Holland might become a very dangerous place for radical English Protestants.

For these reasons the Separatist community considered moving yet again to some place where they might hope to enjoy religious liberty, economic prosperity and their English heritage. There certainly was no place in Europe where this could be done—Holland was the best there was—so they looked to English America. They believed that if they were that far away from the king's governmental officials, they might be allowed to live in peace. This was not a new idea in Separatist circles—the Ancient Brethren's pastor Francis Johnson and others had scouted the Gulf of St. Lawrence in 1596 but decided against settlement. Elder Francis Blackwell took a shipload of 180 of the congregation from Amsterdam to Virginia in 1619, but through a series of tragic mishaps, only 30 survived. Not deterred by these failures, the Leiden group considered several options. They rejected an offer from the Dutch to go to New Netherlands (New York). Guiana was well described in the literature of the time, but they felt the climate and diseases there would not suit their English bodies, and again, there were the Spanish to worry about. Virginia, on the other hand, might be as bad as England, and the Indians were another cause for concern.

In the end, they decided to take advantage of a new option in colonial settlement that would give them a large measure of independence. The two original companies chartered by the Crown to undertake the colonization of British North America ("Virginia") had originally done the work of recruiting and supplying the new settlements. In 1607, the Virginia Company of London, whose authority extended from the thirty-fourth to the forty-first parallels of latitude, and the Virginia Company of Plymouth (England), whose authority ranged from the thirty-eighth to the forty-fifth parallels (the overlap was intentional), each sent out colonists to begin the venture. While the southern settlement at Jamestown managed to struggle through, the northern company at the mouth of the Kennebeck in Maine gave up after a year and the Plymouth Company fell apart.

However, even Jamestown did not grow at the desired rate, so around 1617 the company came up with the idea of "particular plantations" or "hundreds." These were essentially colonial franchises whereby independent investors were issued "sub-charters" or patents that would allow them to settle in a particular area and do all the work of recruiting settlers, developing the property and keeping the population supplied for a period of seven years. If the venture was a success, they could then apply to the company for permanent title to the land they occupied, the amount of acreage to be determined by the number of colonists they had brought over ("headright"). These essentially self-governing "colonies within a colony" became public corporations after the manner of a borough or manor, but were still answerable to the English Crown. The Leiden group, with the help of friends and investors in England, successfully applied for two of these "particular" patents (the first being made out to a man who dropped out of the venture) from the Virginia Company of London. Their plan, if Bradford's statement that they intended to go to the mouth of the Hudson River is correct, was to settle as near as possible to the northern boundary of the Virginia colony and as far away from Jamestown as possible, while still being within their legal territory. As we shall see, this didn't work out as planned.

The other half of the colonial equation was money. These ventures were not cheap. It is estimated that the *Mayflower* voyage cost some £5,000—a huge sum at the time. Even after they sold their homes and as many belongings as possible, the Leiden group didn't come close to the amount required. Fortunately for them, investments of this sort, which were believed to have the potential for a considerable return, were popular among a class of investors we might term "venture capitalists" today, but who were then known as "merchant adventurers." Thomas Weston, a London businessman who professed great sympathy for their religious principles, offered to recruit investors to underwrite the colonial venture. The "adventurers," or speculative investors, of whom there were more than seventy, bought shares in the project at £10 each. The actual emigrants each received a single share for making the voyage and working together for the good of the company, of which they were (minor) shareholders for the seven-year period required by the Virginia Company. Because they didn't think the Leiden community could supply enough reliable colonists, the London investors also insisted they take along fifty-odd additional emigrants that they recruited. The settlers would build the infrastructure of the colony and be supplied with their necessities by the adventurers. They were also to export commodities (anything from codfish and lumber to furs) that could be sold in England to defer expenses or even turn a profit.

It was on this basis, armed with a London Virginia Company patent and implicit permission from the English authorities, that a portion of the Leiden congregation (primarily the younger and more adventurous

members) prepared to emigrate. Reverend Robinson chose to remain in Holland with the majority until it became possible for them to join the initial emigrants in their new American home. They bought a small vessel of sixty tons called the *Speedwell* for their trip, and in July the community traveled south by canal to Delftshaven (now part of Rotterdam). There the emigrants met their new ship and together with those who were staying behind held a service of fasting and humiliation to say farewell and ask God's blessing on the momentous voyage into the unknown.

The *Speedwell* sailed on July 22, 1620, to Southampton in England where the other colonists and a second vessel, the *Mayflower*, were waiting. The *Mayflower* had been hired by the adventurers and sailed to Southampton from Rotherhithe near London where its master and part owner, Christopher Jones, lived. On their arrival, the Leiden emigrants were met with new problems. They had sent two of their number, John Carver and Robert Cushman, on ahead to make arrangements and provision the ships for the Atlantic crossing. Cushman found that the adventurers were determined to change the original agreement so that the colonists were obliged to use all their time working for the company and would no longer be given their own homes at the end of the contract. Cushman reluctantly allowed the changes lest the deal would be called off, but his fellow emigrants were less ready to agree. The dispute delayed their departure, and they had to sell some of their provisions to meet expenses the adventurers would not pay for. The two vessels finally set sail for America on August 5.

However, Mr. Reynolds, the master of the *Speedwell*, soon reported that his ship was leaking badly and they put into Dartmouth for repairs. Setting forth again, the *Speedwell* again began to leak badly and they had to return to Plymouth in Devon. They could find no reason for the problem and reluctantly decided to leave the *Speedwell* and some of the passengers behind, and proceed with the *Mayflower*

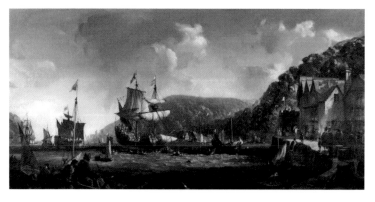

The Mayflower *and the* Speedwell *in Dartmouth Harbor*—painting by Leslie Wilcox (1904–1982), 1971. This represents the first of the two emergency stops in the summer of 1620 occasioned by the leaking *Speedwell*.

alone. It was thought that Reynolds, having gotten cold feet, pressed on too much sail, which strained the standing rigging and pulled the seams open. Once the *Speedwell* was in port, the strain ceased and the seams snapped shut again.

On September 6, 1620, the *Mayflower* under the command of Master Jones left Plymouth for America, leaving perhaps twenty former emigrants behind. William Bradford covers the voyage in a few pages. Despite popular impressions that the little 180-ton vessel (measured by cargo capacity—not displacement as modern ships are) was beset by storms and terrible discomfort, the initial part of the voyage was without incident. When the storms did appear, they were nothing unusual for a transatlantic crossing. A failure of one of the main beams was successfully shored up with a "great screw" (not a printing press) and the providential rescue of John Howland, who managed to seize a loose halyard after being swept overboard. Only two people died during the crossing, a profane sailor and surgeon Samuel Fuller's assistant William Butten—most likely from causes that predated the voyage—and there was one birth (Oceanus Hopkins).

Finally on November 9, 1620 (Old Style), land was sighted. They found themselves at the tip of Cape Cod, a common landfall for early Atlantic crossings. Although they were within a degree of latitude of their goal (41° north), they still had hundreds of miles to go before they could arrive at the mouth of Hudson's River, the northernmost point where their patent was valid. However, as they made their way south along the outer Cape, they came upon the treacherous Malabar, or Monomoy, shoals where hundreds of vessels would be lost over the years. They decided to turn back rather than risk disaster, and on November 11, anchored in Cape Cod Harbor (today's Provincetown, Massachusetts). As Bradford notes, they were very grateful for their safe arrival: "Being thus arrived in a good harbor and brought safe to land, they fell upon their knees and blessed the God of heaven, who had brought them over the vast and furious ocean, and delivered them from all the perils and miseries thereof, again to set their feet on the firm and stable earth, their proper element."

With the decision to remain outside of the scope of their patent in New England, there was some debate as to whether they were still bound by the original agreement. Some individuals wanted to go off on their own—a highly dangerous notion—but they were convinced to remain united to face the challenges ahead. The colony leaders drew up an interim agreement that was signed by virtually all of the adult male passengers to ensure harmony and bridge the gap between the invalid patent and its replacement that would legally establish the settlement. This agreement was very simple and straightforward in its intent of holding the company together during this difficult period, but as the "Mayflower Compact," it has been subsequently (and anachronistically) invested with immense symbolic significance as a founding document of American liberty.

They went ashore to refresh themselves, wash their garments and bedding (thus initiating, in myth, the legendary New England Monday washday) and to explore the strange new land. While their shallop, or workboat, was being repaired and fitted out, an exploring party found that the immediate vicinity was unsuitable for agriculture and settlement. They also saw Indians for the first time at a distance, and making their way inland, discovered a cache of seed corn and a European kettle, which they took. Much has been made of this initial "theft"—and theft it was, but necessary as well. They did pay the owners back with interest the following year. Corn was their most successful first crop and the reason for the famous 1621 harvest celebration we now call the "First Thanksgiving." On their next exploration, they found (and took) more corn and visited a few empty Indian dwellings, from which they pilfered a few things. They also discovered a puzzling grave of a European man.

As winter was drawing near and many people were suffering from colds and malnutrition brought on by the monotonous diet aboard the ship, they needed to find a suitable place to build shelters as soon as possible. They undertook a third expedition (during which the "First Encounter," a noisy but bloodless skirmish with the Indian inhabitants, took place) with the intent of locating a good harbor that their pilot, Robert Coppin, had visited on an earlier voyage. Following the skirmish on the morning of Friday, December 8, they sailed the shallop north in increasingly foul weather. Just off Manomet Point, the heavy seas broke the rudder and the gale snapped the mast into three pieces. The pilot, confused by surf breaking on a beach between two headlands where he thought a channel should be, declared it was an unknown harbor. However, one of the seamen took charge and steered the vessel into a safe anchorage in the lea of an island. They managed to get ashore and somehow started a fire in the rain, around which they huddled that night.

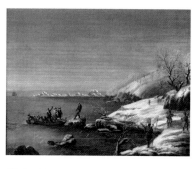

The Landing on Plymouth Rock—Painting by Michele Felice Corne (circa 1752–1845), 1809. One of the earliest representations of the landing, after the woodcut by Samuel Hill, 1800.

The next morning they surveyed the island (Clark's Island—named after the *Mayflower*'s mate, John Clark), and then rested on the following day, it being the Sabbath. On Monday, December 11, 1620, they crossed to the mainland, and according to legend, landed on Plymouth Rock. There is no contemporary mention of the famous rock, and neither of the two people (John Alden or Mary Chilton) whose descendants contended were the first to step on it was

present at the time. The explorers decided that the hill above the landing place was a suitable area for settlement, and they returned to Cape Cod. The *Mayflower* itself crossed Massachusetts Bay and arrived at New Plymouth on Saturday, December 16.

After a Sabbath, three days of exploration and two of bad weather, the colonists began work on the new settlement on Saturday, December 23. Over the next three months, during which half of the passengers and crew died of disease and exposure, various adventures took place. The first little timber-framed houses were built, the Indians' abandoned fields were planted and New Plymouth slowly came into existence. Although they had seen signs of the native inhabitants, they did not encounter any of the Indian peoples until Friday, March 16, when a single man boldly entered the settlement and, much to their surprise, greeted them in English. This was the Abenaki sagamore, Samoset (circa 1590–1653), who had learned English from fishermen in Maine and happened to be visiting the Pokanoket sachem, Massasoit.

That Sunday Samoset brought five other men to meet the English and do some trading, but the English would not trade on the Sabbath, so they entertained their guests and gave them gifts instead. Samoset returned the following Thursday with a survivor of the local Patuxet (the Indian name for the New Plymouth area) band named Tisquantum, or Squanto. Like Samoset, Squanto could speak English, having been kidnapped by the master of an English ship to be sold into slavery in Spain. He managed to escape to England where he lived in London with Sir John Slaney, the treasurer of the Newfoundland Company. Slaney sent Squanto back to America to act as a guide and translator, and he had just returned to his old home a few months earlier, only to find it deserted due to a terrible epidemic (1616–17) that decimated the coastal tribes of southeastern Massachusetts.

Samoset and Squanto told the English that the sachem Massasoit, his brother Quadequina and their entourage were nearby. They wanted to meet with the English and learn their intentions. The Indian contingent appeared on Watson's Hill south of Town Brook, and Edward Winslow went with Squanto to greet Massasoit. Winslow remained with Quadequina while Massasoit entered the Plymouth settlement, whereupon the Pokanoket sachem and Governor John Carver negotiated a treaty of peace that would last for half a century and ensure the survival of the infant colony.

The *Mayflower* returned to England on April 5, 1621. New Plymouth enjoyed a plentiful first harvest in 1621 and welcomed their Indian neighbors to a feast of wildfowl that lasted several days—our First Thanksgiving—to which the Indians contributed an additional five deer. That harvest was subsequently called upon to support another thirty-five colonists who arrived without supplies on the *Fortune*, on December 9. Plymouth received a new patent in 1621, which secured the legal existence of the colony. After two uncertain years, more immigrants arrived and the little colony began to show signs

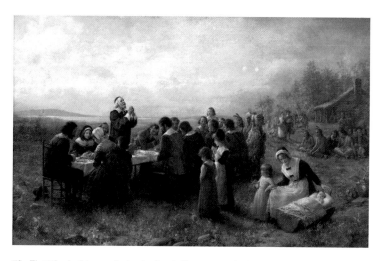

The First Thanksgiving—painting by Jennie Brownescombe (1850–1936), 1914. This famous idyllic autumnal scene has become the standard representation of the famous 1621 harvest feast now known as the "First Thanksgiving."

of stability. Although the agreement with their financial backers fell apart, the Plymouth colonists persevered and took ownership of the debts that encumbered the little colony's early years. By the end of their original contract in 1627, the colonists were well established and ready to expand beyond the limits of the palisaded (fortified) village of Plymouth.

Plymouth From Colony to Community

In 1627, at the end of the seven-year contractual period, families were able to move out of Plymouth Village to the individual farms they had dreamed of from the beginning. Each family was granted property (at the rate of twenty acres per person) along the harbor side between Eel River to Powder Point, with each location decided by drawing lots. In 1632, the northernmost families established an independent parish at Duxbury, the first of several communities created out of what was once part of Plymouth. New towns were also founded within the colony at Scituate (1636), Barnstable (1638), Sandwich (1639) and Marshfield (1640) by recent immigrants and former Plymoutheans.

Plymouth Colony received its permanent patent or charter from the Council of New England in 1630, which gave the colony land in southeastern New England south of Massachusetts Bay and east of Narragansett Bay, as well as extensive territory on the Kennebec River in Maine. It was not long before the little colony was joined by others. The Massachusetts Bay Company, far larger, richer and more powerful, arrived on Plymouth Colony's northern border in 1630, and in 1636, the colony of Rhode Island and Providence Plantations was established on the west side of Narragansett Bay, cutting off any opportunity for further expansion. Between 1643 and 1684, Plymouth Colony joined with three of her New England neighbors, Massachusetts Bay, Connecticut and New Haven (then a separate colony), to form the New England Confederation for the common defense against the French, Dutch and Indians.

By the 1660s, the Mayflower generation's leadership had passed away—as had their benefactor, Massasoit—and the succeeding generation was embroiled in the tragic King Philip's War (1675–76), when Massasoit's son Metacom (or King Philip to the English) made a last desperate attempt to preserve the inheritance of his people. In 1675, hostilities broke out in Swansea, the colonial town just north of Pokanoket (now Warren, Rhode Island) where Metacom's band

lived. The war spread north to New Hampshire and Maine, and as far west as Connecticut. Not all of the Indian communities sided with Metacom. Many who had converted to Christianity fought with the English or remained neutral. The English, however, tended to distrust the converts and confined many of them on coastal islands such as Deer Island in Boston Harbor or Clark's Island in Plymouth. For the most part the Indian communities on Cape Cod did not participate in the war, and there was only one incident in Plymouth itself, when the Clark garrison house was attacked. On Sunday, March 12, 1676, Indian fighters attacked the fortified house of William Clark on Eel River while Mr. Clark was at church. There were two families in the house at the time and eleven people were killed. The only survivor was Thomas Clark, who was about eight years old. Tom had received several blows with a tomahawk and was left to die, but was still alive when help arrived. A silver plate was made to cover the holes in his skull, and despite the primitive surgery methods of the day, he lived for a number of years as "Silver-headed Tom." The Clark site is believed to be under the lower parking lot at Plimoth Plantation.

By July 1676, the war was all but over, and the surviving Native American combatants were rounded up for punishment. An informer identified the leaders in the Clark family murders, which included Totoson, Tispequin and another man. They confessed and were executed. Like most of the events of the terrible New England war, the Clark garrison massacre was deadly and brutal—for everyone involved. The war effectively ended on August 12, when Alderman—a Wampanoag fighting with Captain Benjamin Church—killed Metacom, although sporadic fighting did continue in the north for two more years. King Philip's War was one of the bloodiest and most costly in American history. One in ten soldiers on both sides was injured or killed. It took many years for Plymouth and the other colonies to recover from damage to property.

In the troubled aftermath of the war, a different sort of threat challenged Plymouth Colony. The New England Confederation was dissolved in 1684 when the Massachusetts charter was revoked. In 1686, James II sent Sir Edmund Andros to Boston as governor of the "Dominion of New England," which incorporated Massachusetts, Maine, Plymouth Colony, Rhode Island, Connecticut and New Hampshire, with New York and New Jersey added in 1688. Although both Andros and his king were deposed in 1689, Plymouth remained without legal status as a colony, as it had never had a royal charter. Plymouth had relied on the patent it had received from the Council for New England in 1630, which, while technically lacking the authority to confer self-government, did in fact provide the lawful basis for the colony as long as no serious challenge arose. However, the Council for New England had dissolved in 1635 and Plymouth's agents in London were unable to secure a new charter. In 1692, the "Old Colony," as Plymouth Colony became known, was swallowed up by Massachusetts

Bay, its powerful neighbor to the north. Plymouth became just a county town (the colony having been divided into counties in 1685) rather than a plantation or colony, and the Pilgrim adventure became merely a part of the hallowed past. Henceforth our story is just about Plymouth the *town*, and while it is the largest town in area in Massachusetts, that is not the same as being an independent colony or state.

Although Plymouth encompasses about ninety-six square miles (estimates vary), the town's population has been concentrated in the northeast corner, near the downtown area, throughout most of its history. The original Plymouth Village was laid out on First Street (later Leyden Street) in 1620, with common fields to the north and south. In 1623, a three-mile strip along the harbor from Nelson Street to Jabez Corner was divided into assigned planting grounds for the inhabitants. The early settlement centered on the Town Brook neighborhood, with Plymouth's oldest "suburb," Wellingsley (or Hobshole), a mile south of Town Brook. The only other notable areas of settlement before the nineteenth century were Eel River Village (today's Chiltonville) and Manomet Ponds, from Bartlett Pond to Fresh Pond and along Beaver Dam Brook. The North Plymouth neighborhood between the Kingston line and Plymouth Village was not developed until the founding of the Plymouth Cordage Company in 1824. Consequently, most of the points of historical interest are near the old downtown area.

From the time of the Pilgrims until after the American Revolution, Plymouth was supported through agriculture and fishing. The pine barrens to the west and south of the town center, almost useless as farmland, were entirely uninhabited until the nineteenth century. Even the earlier Wampanoag inhabitants had stayed on the fertile bottomlands along Plymouth's brooks and wetlands, and only ventured into the barrens to hunt. Old Yankee families scratched out livings in semi-fertile fields and pastures, and brought back catches of cod to be dried on acres of "fish flakes" along the waterfront. Around Hobshole to the south and along the shore below the lots on Court Street, acres of drying fish lent an inescapable odor to the neighborhood when the onshore wind blew. The cured fish were barreled and shipped aboard Plymouth schooners to Spain and the West Indies and provided a living for the Plymouth seamen from before the Revolution until well into the nineteenth century. The ships also needed rope for their rigging, cotton canvas for their sails and forged anchors to hold them on the fishing banks, as the cod and mackerel fishermen caught their fish using long lines and hooks. In time, Plymouth began making rope, cotton duck canvas, anchors, barrels, fishing lines and even the ships themselves.

Plymouth's shipbuilding industry, which had begun in Pilgrim times, occupied a number of shipbuilding yards, the locations of which, unfortunately, are not clear. Plymouth historian William T. Davis located two early eighteenth century yards on the town waterfront, one

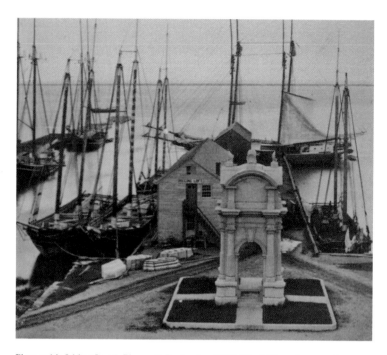

Plymouth's fishing fleet & Plymouth Rock, circa 1870. The fishing schooners shown here were the backbone of Plymouth's commercial fleet.

below the foot of Middle Street and the other on the north bank of Town Brook, where the entrance of Brewster Gardens is today. Others were apparently up and down the shore wherever space and wood to build with could be found. Most of the boats were small coastal vessels suitable for the fisheries, but larger ships were constructed as well. Fishing and trade to Liverpool, Spain or the West Indies employed many Plymouth men and ships. The wealthiest families of eighteenth-century Plymouth acquired their wealth through trade and shipping. The Plymouth fleet before the American Revolution consisted of about seventy fishermen and twenty merchant vessels, each weighing about thirty to thirty-five tons. The fishing trade concentrated on cod and mackerel, which were cured and exported to the West Indies and southern Europe. Trade was bound up in the colonial trade of the British Empire, which limited the venues for Plymouth ships. Although the Plymouth fleet was largely destroyed or put out of action during the Revolution, it was also freed from the restrictions of British rule.

After the wartime dislocation of trade and commerce, Plymouth worked hard to restore its fleet. Twenty-two Plymouth vessels were launched between 1784 and 1801, and another sixty-two between 1802 and 1813. The town enjoyed an unprecedented burst of prosperity at the turn of the nineteenth century. As William T. Davis states in *History of Plymouth*: "An atmosphere of comfort and wealth began to pervade a

community which had long felt serious burdens, and had never before enjoyed the superfluities of luxurious living." There was a short-lived Plymouth newspaper, the *Plymouth Journal* in 1785, and in 1797 the Plymouth Aqueduct Company was incorporated to construct the first aqueduct in the United States, which would bring water through wooden pipes from near Billington Sea to the downtown area.

This period of prosperity was short lived. The terrible (for New England in particular) Embargo of 1807, during which all American ports were closed, threw Plymouth into economic depression. Plymouth petitioned President Jefferson to lift the crippling embargo in 1808, but though they received a solicitous reply, the embargo continued. The town, like the rest of New England that contemplated secession from the Union over the embargo and the highly unpopular War of 1812, continued to petition and protest to no avail. Its fishing fleet was reduced to only five vessels by 1815.

Once again, Plymouth bounced back. New vessels were built and put into service, so that forty-six fishing boats and a hundred trading vessels were putting out of Plymouth by 1820. Plymouth shipbuilding was still the top economic performer in 1837 with the production of twenty-two vessels worth $214,280, although the trade would precipitously decline during the following decade. Fishing in particular remained central to Plymouth's financial health. There were consistently more men employed in the fisheries than any other industry, and fishing was one of town's the top money producers until the Civil War. However, although shipping and fishing remained important elements of the Plymouth economy, they were now joined by the new wave of industrial development that would soon dominate the region and which brought about considerable change in the old town.

When the Industrial Revolution arrived, numerous mills and factories were built along the town's small brooks. Rolling mills and foundries processed local bog iron into nails, tacks, anchors and "hollow ware" (pots and pans). Cotton and woolen cloth was woven in modest factories, and imported fiber was made into rope and twine in several ropewalks, including what would become the world's largest manufactory of rope, the Plymouth Cordage Company. Finally in the early twentieth century, the cranberry industry brought a new usefulness to the town's swamps and bog land. Also, the industries spurred immigration from Germany, Ireland, Italy, Portugal and Finland, changing the demographic makeup of Plymouth's population forever.

Today, Town Brook hardly inspires the image of an industrial waterway, despite the existence of the re-created Jenney Mill or the last surviving fragment of the stream's mill-lined past near Deep Water Bridge. Even less suggestive are the other streams that were once used for water power, such as Hedges' Brook in North Plymouth, Eel River, Shingle Brook or even little Hobshole Brook. Yet until water power was superseded by that of steam in the late nineteenth century,

most of the town's industrial capacity could be found on these modest streams. The public value of Plymouth's primary waterway, Town Brook, was recognized from an early date, and rights to employ the water power were licensed to various parties.

The first privilege on the brook was established just east of Deep Water Bridge, where Billington Street crosses over the brook and where the Plymco plant was located until recently. John Thomas built a leather mill that processed leather hides here about 1771. Solomon Inglee erected a snuff mill on the site in 1788, and also built the fine brick house on the southerly bank of the brook as a residence. The site passed through several hands before a cotton mill was built in 1812, which promptly burned down the following year, and was replaced with a four-story building containing sixteen hundred spindles and thirty-four looms, on which fifty-four workers manufactured about one thousand yards of cotton cloth a day. That mill burned down in 1843, and the site was bought in 1855 by the Samoset Mills Corporation, which built a new factory for the manufacture of cotton thread. In 1872 it was converted to the manufactory of printed cotton cloth, and in the 1880s became the "Standish Mills." In 1893 the mill was converted to the manufactory of woolen cloth. Standish Worsted flourished with military contracts during the World War I, but there was a considerable drop in custom after the early '20s, and the mill was closed and abandoned in 1930. A surviving section was employed by the Plymco Millwork Company to make windows from the 1960s to the early 1990s.

The second privilege was located where the stone bridge crosses Town Brook from Billington Street. A forge was built there by Solomon Inglee before 1790 and used for the manufacture of anchors, ploughshares and sleigh shoes. It came into the possession of Nathaniel Russell and Company in 1806, which installed a rolling and slitting mill for the production of nails. The earlier production of nails was done as piecework in Plymouth homes during the winter months, as the heating and heading could be easily accomplished on an ordinary hearth. The invention of nail-making machinery by Jacob Perkins made the old craft work obsolete, and the new mills handled the entire process. The Russell mill was leased in part by Oliver Ames from 1807 to 1813 to produce shovels. Ames later became famous for his shovels after he moved back to North Easton and founded his own company. The mill site, with the rest of the Nathaniel Russell and Company property, was sold to the Plymouth Mills Company in 1854. It eventually became the Plymouth Mills "Upper Works," which operated until 1926. The buildings stood empty until they were removed in the 1930s.

In 1800 Heman Holmes and Zadock Packard bought the third privilege, which was where the covered footbridge is today. They operated a forge, which they sold to Nathaniel Russell & Co. in 1815. Nathaniel Russell Jr. sold it to Jeremiah Ferris and Oliver Edes in 1844,

Plymouth Mills, Lower Works, circa 1885. Begun as an anchor forge in 1800, the mill buildings burned in the 1960s and the dam was removed in 2000. Today's covered footbridge is where the building at the left once stood.

who had moved their company for the manufacture of rivets from Marshfield to Plymouth. Oliver Edes had invented a rivet machine that would cut and form rivets from wire, which allowed America to effectively compete with European imports for the first time. The factory became the nucleus of the Plymouth Mills Co. (incorporated 1845), and after 1854 it became the corporation's "Lower Works." Edes had sold out to Ferris in 1850, and Edes became partners with Nathaniel Wood to make zinc shoe nails, tacks and rivets on Shingle Brook in Chiltonville.

The two Plymouth Mills sites continued to grow and prosper through the century. Plymouth Mills eventually acquired the Robinson Iron property at the fourth privilege in 1898, which was used to send electrical power to the manufacturing sites upstream. By 1926 it was determined that Plymouth Mills was no longer viable, and the plants closed. By 1930 the assets had been disposed of and the property was sold to the town. Part of the lower mill was used by the town as headquarters for the Plymouth Highway Department, and as a storage facility by Ronald Reed until 1966, when a fire destroyed many of the old structures. Another section at the westerly end of the complex became the Arthur Ellis & Sons curtain factory in 1937, which moved to its current site on Court Street before the fire.

The fourth privilege, where the dam above the Summer Street playground is today, was bought from George Watson by his son-in-law Martin Brimmer of Boston in 1792. Brimmer established an oil mill and a gristmill in addition to the first rolling mill and slitting mill

in Plymouth. In 1805 his widow Sarah Brimmer sold the ironworks to N. Russell & Co., and it was sold to the Robinson Iron Works in 1866. Although the Robinson Works employed about two hundred men, the production of nails ceased in 1890 and the rolling of plate in 1897. The abandoned plant suffered a fire in 1900, and in September 1906, the dam above the mill broke, sweeping away not only parts of the surviving factory buildings, but also the topsoil from the low area to the east.

The location east of Newfield Street (which may have been a "privilege" of its own) was first used for the gristmill as mentioned earlier, and later to grind clay to repair the furnaces. After the main buildings in the present playground area were removed, the privilege supported a small tack factory owned by Plymouth Mills from about 1905 until after 1920. There also had been an extensive tannery on the easterly end of this area built by William Crombie in 1786 or earlier.

The fifth privilege was where the dam that created "Poorhouse," "Alms House" or today, "Jenney" Pond once powered the 1636 Jenney gristmill and now supports its re-created successor. The old gristmill, as we have seen, survived until it burned in 1847. However, it had become the property of the Robbins Cordage Company in 1838, and the Robbins ropewalk then dominated lower Town Brook. The long ropewalk extended along and over Town Brook from where the Jenney Grist Mill is today, under the Market Street Bridge, to a spot near today's entrance to the Brewster Gardens. Deacon Josiah Robbins founded the Robbins Cordage Company before 1817 and went out of business about 1862.

The next use of the privilege was when Samuel Loring purchased the land in 1863 and moved his small tack company from Duxbury. In 1886, Loring's son-in-law and partner, John Parks, enlarged the mill, adding electrical and steam power and increasing production. By 1900 the firm was reorganized as the Atlas Tack Company with headquarters at Fairhaven, but as was so often the case with monopolies at the time, the smaller concerns were sacrificed to the larger goal, and the old Loring and Parks mill was closed in 1903.

The factory was apparently vacant until the Bradford and Kyle Company bought it in 1905, which moved from its previous location in the old Methodist church on the corner of Robinson and Market Streets. Mr. Bradford, a Plymouth mechanic and inventor, devised a method by which copper wire could be pulled to a previously unattainable diameter of 0.0015, which was vital to the evolving electrical industry. In 1905, Bradford and Kyle employed thirty-five men, making wire thin enough that one pound of copper made twenty-five (or eighty in another report) miles of wire. They also made insulated wire covered with silk and linen for telephones, corsets and, later, radios. The company moved in 1966 to Lothrop Street and the Town Brook mill was demolished in 1968 as part of the Plymouth Redevelopment scheme, making way for the re-created Jenney Grist Mill.

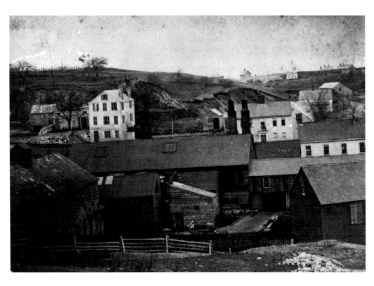

The Robinson Iron Works, circa 1890. Initially built by Martin Brimmer in 1792, the rolling mill was enlarged in the 1850s as the Robinson Iron Works Company.

The sixth privilege was located above where the Market Street Bridge crosses Town Brook. Here, in 1672 George Bonum built the first industrial mill in Plymouth, a fulling mill, behind the houses on the lower end of Summer Street north of the lower gristmill. At that time, Market Street didn't continue down Spring Hill to the Market Street Bridge, which was first built around 1666, but turned west into Summer Street. To cross Town Brook, one had to double back diagonally down the steep bank on Mill Lane beside the mills. Fulling mills cleaned and felted the nap on woolen cloth by pulling and pounding the fabric with water and soap.

By the turn of the century the privilege supported not only the lower gristmill but also the Bradford Joint Company. Louis Bradford invented a new sheet-metal joint for wooden bedsteads in the late 1860s that proved very popular. The Bradford Joint Company was founded in 1870 and shared water power with the gristmill. The new joint was sold across the United States in the 1880s. In 1908 the company expanded its efforts into the repair of automobile and boat engines, but was obliged to close in 1912. The lower gristmill at 47 Market Street, operated by Ichabod Morton & Co., remained in business until the mid-1920s.

Besides those businesses and industries that were accorded particular mill privileges, there were a number of other operations that bordered Town Brook. William R. Drew established a small foundry in the 1840s at the mouth of the brook. It made stoves and "hollow ware" (tinware, iron pots and kettles) throughout the Civil War, after which it was incorporated in 1866 as the Plymouth Foundry Company. The

foundry manufactured a number of sorts of cast-iron stoves (one advertisement in 1893 claimed 1,080 different models!) throughout the years in which such cooking and parlor stoves were both popular and essential, but when gas, electric stoves and central heating became more popular, business waned. The Plymouth Foundry closed in 1935, after several years of intermittent operations.

The waterfront was a center for commerce and transportation, but the dominance of shipping passed to the railroad after the Civil War. Some industries such as the Robinson Iron Works and the Plymouth Cordage Company continued to use their own schooners to import coal, ore, hemp and other supplies by sea, but from 1845 on, other industries began to use the Old Colony Railroad. One such mill was the Plymouth Woolen Mills, founded in 1863 by Dwight Faulkner and located where the Radisson Hotel and its parking lots are today. Plymouth Woolen made mostly flannel suiting cloth during its early years. It was sold to Sawyer and Douglas of Franklin Falls, New Hampshire, in 1879, who considerably enlarged the facility in 1890, and later sold it in turn to W.W. Wood, founder of the new American Woolen Company, around 1900. The Puritan Mills, as the Plymouth facility was then called, prospered during World War I by concentrating on the explosive need for woolen service uniforms and blankets. It continued to enjoy a high volume of orders for suiting and flannels into the early 1920s, but business sharply declined thereafter. Puritan Mills continued to operate in a depressed condition until it closed in 1955.

Another mill even more closely associated with the railroad was the Emory shoe factory, which was on North Park Avenue where the Richard's Wine & Spirits and the Rockland Trust office is today. The Old Colony Railroad donated the land in 1873 and the town raised money to build a large four-story factory to attract a shoe company to Plymouth. The offer was accepted by the F. Jones & Co., but the company moved away after two years, selling the property (in the family) to the Francis F. Emory Co. in 1875. Production ceased in 1899 when the Emory Company moved to Brockton, and no one took its place.

Almost across the street from the Emory factory, where the Ming Dynasty restaurant is today, was the Plymouth Preserving Company, a cranberry canner. By 1896, a branch of Chandler's Livery Stable occupied the site, in addition to its primary location on Middle Street. By 1912, the site was occupied by the Bradley, Ricker Co., which manufactured carpets. The Bradley Company had expanded by 1919 and occupied a much larger building than any of its predecessors. However, by 1926, the rug company was sharing its premises with the Gurnet Worsted Company and the Plymouth Yarn Company, and by 1943 the site was a bowling alley before the restaurant and other tenants replaced it.

Just east of the site just described was the Ripley & Bartlett Tack Factory, where Al's Pizza is now. Founded in 1879 over the Plymouth

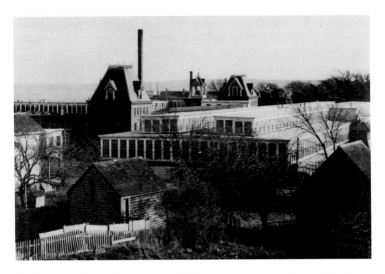

The Plymouth Woolen Company, circa 1890. Later known as the Puritan Mills, this factory was where the Radisson Hotel is today, near the waterfront and the former railway. It manufactured woolen fabrics from 1863 to the 1950s.

Mills machine shop on Town Brook, Ripley & Bartlett moved to the waterfront site the following year. The company expanded in the 1920s and survived strong competition in the following decade to outlast all of the other tack factories in town, before it closed about 1960.

Another waterfront success was the Edes Manufacturing Company, which set up shop off Loring Street after moving from Shingle Brook in 1892. The company made electrical components, engraving plates and bronze souvenir casts of Forefathers' Monument. It was sold to Revere Copper and Brass in 1959. To the east of the Edes company, a building later nicknamed the "Clam Factory" was erected in the 1920s as a canning plant, which in turn was bought by United Shoe Machinery and then Ocean Spray, before becoming part of an office complex. It was built on or near the site where the C.E. Taylor Wooden Box factory was located in 1912. In 1927 the plant, identified as the Puritan Canning Company, was already out of operation and vacant. Presumably it had been a clam chlorination and canning operation, as there was a brief efflorescence of the clamming trade in Plymouth in the years around World War I. A guide to New England from 1916 states: "1000 acres of flats in the harbor are now planted with clams. Nothing of the product is wasted. The clams are graded as carefully as Western apples; the shells are used for poultry feeding and road making, and the canning business furnished clam bouillon as a by-product. By this economic handling a profit of $500–$700 an acre is readily obtainable."

Those flats had been largely barren in 1910, and may have become so again. There was an earlier clam canning plant, the

Andrew Kerr Company, on the Craig wharf just north of the present State Pier. Unfortunately, a typhoid outbreak associated with clams and water pollution in 1925 brought a decline to this promising business. The Puritan Canning plant was owned by the National Cranberry Company in 1943, and was later bought by the United Shoe Machinery Corporation in the 1950s before briefly becoming "Cranberry World."

The other major industry located on the waterfront was the George P. Mabbett & Sons Woolen Company. The Standish Worsted Company had employed Mabbett before he retired in 1899 and founded George Mabbett & Sons in 1900 on Water Street, where the Plymouth Rock Boot & Shoe Company was previously located. Mabbett's prospered during World War I. After 1918 the company dedicated its production to the finest quality worsted for men's suits, and unlike the nearby Puritan Mills, which had difficulty in the competitive civilian market, Mabbett's expanded its facilities in 1921 and again in 1926. It also kept up to date with the latest technology, installing automatic looms between 1925 and 1930. In 1940 the firm employed about three hundred workers. Mabbett's continued in operation after the other woolen mills closed, weathering the notorious Goldfine scandal of the Eisenhower years. Sherman Adams, Eisenhower's presidential assistant, was cited by Congress for accepting bribes from Bernard Goldfine, owner of many woolen mills, who "gifted" Adams a vicuna coat and picked up several of his hotel bills. Mabbett's finally closed in the early 1960s, and the building became Isaac's Restaurant.

Eel River and its southern tributary, Shingle Brook, were second only to Town Brook in the number and variety of industries that they supported over the years. Interest in the economic possibilities of the river began as early as 1701 when Elder Thomas Faunce headed up an effort to induce a greater number of alewives to spawn by digging a watercourse connecting the headwaters of the river to Great South pond. Although the watercourse was dug, the fish were not impressed. At an early date there apparently was a gristmill about where Shingle (or Double) Brook passes under Sandwich Road. The first industry to exploit the swift waters of the river was a cotton mill built in 1812 where Eel River passes under Sandwich Road. Reorganized in 1844 as the "Plymouth Cotton and Woolen Company," the factory produced cotton thread and cotton duck canvas. The duck found a ready market in the age of sail, and the mill was often referred to as the "Old Colony factory" from its famous brand. It is best known, however, as the Hayden Mill from manager Edward B. Hayden. Sails were produced for many vessels, including racing yachts such as the "Puritan," the "Mayflower" and the "America," which won the first America's Cup using "Old Colony" canvas. The six-story yellow mill, which employed sixty-five people in 1835, was largely staffed by women who tended the two thousand spindles in the spinning lofts (although men ran the forty looms on the lower floors), and lodging was provided for them around

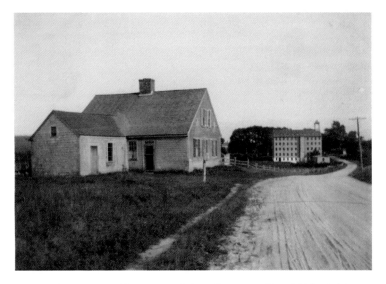

Hayden Mill, circa 1900. This six-story Chiltonville cotton mill on Old Sandwich Road was built in 1812 and burned down in 1913.

what is now known as "Forges' Green." Raw cotton was brought to the mill in "land barges," large wagons pulled by four horses. The Hayden Mill closed in 1897 after Mr. Hayden's death, and it was destroyed by arson on July 3, 1913.

The next industry to exploit the Eel River was Nathaniel Russell & Co., which erected a granite rolling and slitting mill at the dam upstream from Hayden Mill in 1827. This mill acted in cooperation with the company mills on Town Brook in the manufacture of nails, barrel hoops and the like. In 1855 the Russell mill site was sold to the Russell Mills Corporation, which replaced the old ironworks with a new mill of brick for the production of cotton products. In 1873 the cotton mill employed one hundred persons and processed twenty-five hundred pounds of raw cotton each day, using fifty-two looms, fifty carding machines and twenty-eight spinners. Southern competition put the Russell Mills cotton duck factory out of business in 1897 (some of the machinery going to Georgia), and the mill was transformed into the Columbia Rubber Company by the Boston Woven Hose and Rubber Company, which also acquired the Hayden site as a source of power. The Boston Woven Hose and Rubber operation closed in 1929 and the Russell Mills buildings burned down in 1937. There were, in addition, smaller factories farther upstream above Russell Mills Pond, including a barrel stave mill built by Samuel Bradford in the 1830s at the western end of Russell Mills Pond and a cotton-batting mill farther upstream close to the Long Pond Road.

Shingle, or Double, Brook was formed by the juncture of three brooks, which when they were dammed formed Forge, or Forges',

Pond. The brook ran from the pond under Sandwich Road and then under Jordan Road to connect with Eel River. It was at the easterly outflow from Forges' Pond that a nail factory was built around 1830. In 1850 Oliver Edes and Nathaniel Wood bought it and moved their zinc operations there from Town Brook. They manufactured zinc shoe nails, rivets and other items there, in one of the earliest zinc rolling mills in the country. In 1858 the partnership was dissolved, with the Edes Company retaining the Forges' Pond mill while Nathaniel Wood & Sons built another zinc mill just down the brook. The Edes Company, which had bought its own zinc mines in Virginia in 1879, found an even more profitable line in the manufacture of zinc battery plates in 1889. Edes moved in 1892 to the Plymouth waterfront. The Forges' Pond and Shingle Brook mill sites were sold to Eben Jordan of Jordan Marsh and Company for his horse farm at about that time. Farther down the brook another rivet mill was in operation in 1821 under the management of local inventor Timothy Allen, who patented a very early rivet machine in 1826 (apparently the one Oliver Edes would later improve upon). There was also a sash and blind manufacturing plant on the brook in 1857, where it passes under Jordan Road. Another small manufactory on the Eel River was the Morton Thimble factory, which made the elliptical metal pieces that are fitted into the eye splices of ropes and cables.

There were still other mills in the southerly part of the town, although there is little beyond chance mentions in the available period sources to attest to their existence. A silica factory that processed beach sand for the production of paint was briefly established below the bluff upon which the Hotel Pilgrim once stood (which is just before the juncture of Warren Avenue and Plimoth Plantation Highway). It operated for a few years and closed in 1898. There was another cotton thread factory at the Manomet Ponds mentioned as early as 1815 by Samuel Davis.

Russell Mills, circa 1910. Developed by Nathaniel Russell as an iron mill in 1827, the factory complex became a cotton mill in 1885 and then the Boston Woven Hose and Rubber Company in 1903.

There was also a barrel stave works on the Agawam River on the west side of the Agawam Road at the southerly extremity of the town in 1857.

Changing economic conditions eventually destroyed each of these local industries in turn. Farming departed first as the rocky New England soil was superseded by the fertile Great Plains. Ironwork moved to where coal and ore mines promised far more economical production, and the cloth mills literally "went south" to where a

cheaper workforce could be found (before moving overseas in the present globalization of the world economy). The fishing industry suffered major setbacks during the American Revolution and the War of 1812, when the fleets of schooners and sloops were destroyed, and eventually salted fish gave way to the refrigerated fresh catches by mechanized fleets working out of cities such as Boston. The demand for rope and binding twine dried up as sailing ships disappeared and new harvesting technology made the old baling machinery obsolete. Cranberries remain, but the production of the massive new bogs in Wisconsin and Washington have long surpassed Plymouth's small, inefficient bogs. The town of Plymouth suffered economic stagnation in the mid-twentieth century as its former economic basis evaporated, but a new industry arose as a partial substitute—tourism, now the world's single greatest commercial engine.

Plymouth has attracted visitors interested in the romantic history of the Pilgrims since the late seventeenth century. During the early nineteenth century, Plymouth's extensive woodlands and seashore also attracted sportsmen who came to hunt, fish and relax. When the Old Colony Railroad linked Plymouth with Boston in 1845, a new market for summer visitors opened up. Families traveled to Plymouth to enjoy both the historical amenities and the beauty of the town's natural features. Hotels, boarding houses and summer cottages were built to support an increasing number of long-term leisure patrons.

Many of the visitors fell in love with Plymouth's natural and historic charms and bought properties where they could return year after year. However, tourist numbers only became economically significant in the mid-twentieth century, especially after the construction of Plimoth Plantation in the late 1950s. The town's unique heritage makes this business a natural resource for income, for, as was once said about the island of Malta, there is more history here than can be consumed locally. Modern pilgrims have been coming to Plymouth for generations to see where New England began and to try to conjure up the well-known scenes of the landing, the first winter and the "First Thanksgiving."

Plymouth cranberry bog. This well-kept bog is on Watercourse Road, built to enable Plymouth's early aqueduct and present water supply. Note the ditches by which the bog is flooded each fall.

There is even a candidate for the first tourist—Samuel Sewall, the Boston magistrate. In 1698, after Sewall was appointed to preside over the circuit court in Plymouth on a rotating basis, he stayed at Cole's Ordinary, which he tells us had been Edward Winslow's house and was the oldest in Plymouth. This house was located on Leyden Street just

east of the old post office. On his first visit to Plymouth, he walked out in the morning and visited the (Jenney) gristmill, turned up the lane to Burial Hill and came down by the meetinghouse, tracing a route over which thousands of tourists would follow after him. In 1702, he was gratified to meet Isaac Robinson, son of the Pilgrims' pastor, "But to my disappointment he came not to New England till the year [1631]." This interest in the first immigrants foreshadows the later emphasis on the "old comers" (who came before 1624) and eventually the narrower focus on the *Mayflower* company.

The centennial year of 1720 apparently passed without special notice. The Pilgrims (or "the Forefathers," as they were known before the term "Pilgrim Fathers" came into use at the end of the eighteenth century) were honored on a local basis as the founders of the town, and recognized regionally as the first New Englanders. The key to the interest in the virtuous and humble Plymouth Forefathers or Pilgrims was their adoption by the New England intelligentsia as everyone's honorary forebears. "Forefathers" has a local connotation—every American town has its founders and forefathers. The term "Pilgrim Fathers," on the other hand, was more general. The Pilgrims, while not one's own forefathers, could be honored by non-Plymoutheans as the founders of New England, and by extension, Anglo-America in general.

Plymouth's career as a historic shrine and place of pilgrimage began in earnest when the commemoration of the Pilgrims went beyond the text and the sermon. The first step was the establishment by the Old Colony Club of Old Colony or Forefathers' Day in 1769, a holiday celebrating the arrival of the Pilgrims at Plymouth. One of the earliest purely American holidays (Thanksgiving for example having European Protestant antecedents), Forefathers' Day not only increased interest in the Pilgrims, but was also responsible for the elevation of the rock to canonical status as Forefathers' or Plymouth Rock. In 1774, amid the tensions preceding the Revolution, the Plymouth Patriots chose the rock as a symbol to increase Revolutionary fervor. Plymouth Rock therefore became the primary focus for anyone interested in the Pilgrims, and this interest spread throughout the region and beyond in the early days of the republic. In 1820 the new Pilgrim Society took over the observation of Forefathers' Day in Plymouth and erected Pilgrim Hall in 1824 as a meeting place and museum for people interested in the Pilgrims. The 1820 meeting was addressed by the president of Harvard and a young lawyer named Daniel Webster.

The most significant development was the arrival of the railway in 1845, when the Old Colony Railroad built the up-to-date Samoset House offering rooms and meals. Now it was not only possible to reach Plymouth in a few hours in relative comfort, but also there were acceptable places for families to stay. Plymouth's first guidebook, W.S. Russell's *Guide to Plymouth and Recollections of the Pilgrims*, was published in

1846. On August 1, 1853, the Pilgrim Society hosted an unprecedentedly large celebration to announce plans for the erection of a monument to the Pilgrim Fathers and a canopy over the lower half of the rock, the upper half having been moved for protective custody to Pilgrim Hall in 1834. The occasion was dubbed "Forefather's Day thawed out" by a local wag referring to the traditional December 22 Pilgrim holiday, but the Pilgrim Society had made the sensible decision to use an August 1 anniversary (of the 1620 departure from Delftshaven) to schedule their event in the more hospitable summer season. A massive parade including politicians from Washington marched through decorated Plymouth streets to the Training Green, where a canvas pavilion was pitched in which dinner was served to twenty-five hundred guests. This event received national press coverage, including an article in *Harper's Monthly*, and provided great PR for the town.

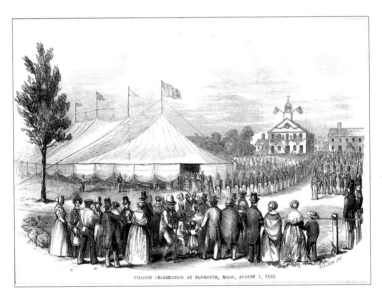

PILGRIM CELEBRATION AT PLYMOUTH, MASS., AUGUST 1, 1853.

"Forefathers' Day thawed out," August 1, 1853. The Pilgrim Society began its campaign for a monument to the Pilgrims with a parade, speeches and banquet for twenty-five hundred on the Training Green. The real Forefathers' Day is December 22.

The continued exposure of the Pilgrim story in print and art and at later grand celebrations helped make Plymouth a major tourist destination during the late nineteenth century. More hotels, such as the Hotel Pilgrim (formerly the Clifford House, which was renovated by the Brockton and Plymouth Street Railway in 1893) or the Columbia Pavilion on Plymouth Beach (1883), opened for business. Steam ships, which had been coming to Plymouth from time to time since 1818, established regular service with the Boston and Nantasket Line, augmenting the railroad passenger service, and various restaurants

and ice cream parlors sprang up to serve them. It wasn't the Pilgrims alone that drew these visitors, for Plymouth's natural resources such as the beaches, the ponds and woodlands were equally popular.

The high point in Pilgrim celebrations was the tercentenary of 1920–21. George P. Baker's pageant, *The Pilgrim Spirit,* employed over 1,200 Plymouth and area residents and was watched by over 100,000 visitors in August 1921, including President Warren G. Harding. The tercentenary also inspired a number of memorials and commemorative monuments that gave the tourist something more to look at than just Plymouth Rock, Forefathers' Monument and Pilgrim Hall. The automobile now replaced the railroad as the primary conveyance to Plymouth and the Brockton and Plymouth Street Railway switched to

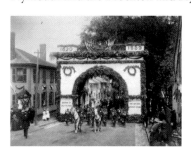

Ceremonial arch, North Street, August 1, 1889. The celebration and parade for the completion of Forefathers' Monument, for which many downtown buildings were decorated and ceremonial arches erected.

buses in 1928, while most of the Boston and Nantasket vessels were destroyed by fire in November 1929. The townsfolk were often ambiguous about the demands of the tourism industry and wavered between support and antagonism, especially after the industrial base began to decline in the 1930s. Plymouth failed to vote funds to operate the information booth and other services in 1939, when public support for tourism was reduced to the voluntary efforts of Miss Alice S. Barnes. She was able, with a pittance from the town, to send 5,700 items of "Pilgrim-Plymouth literature" to 1,250 inquirers in 1940. Nevertheless, tourism continued to thrive.

Another contribution to the tourist experience was the restoration and opening for visitation of a number of old houses with Pilgrim associations. There had been several old houses pointed out in earlier guidebooks, but they all remained private residences and several were later torn down. The Edward Winslow House on Winslow Street, which was "restored" in the Colonial Revival style by Joseph E. Chandler in 1898, was temporarily opened to the public during the 1896–7 Historical Festival and pageant to raise money for the new Unitarian church building. The General Society of Mayflower Descendants bought it in 1940. The first house to be actually acquired for preservation was the Jabez Howland House on Sandwich Street, which was bought by the Howland Society in 1912, but not restored by Strickland & Strickland until 1941. The Antiquarian (Hedge) House, which had been displaced on Court Street by Memorial Hall was acquired by the Plymouth Antiquarian Society (founded in 1919) and opened in July 1920. The Harlow House was bought by the Antiquarian Society in 1920 for $3,000 and opened temporarily to

the public in 1920 and 1921, and following restoration work by Joseph E. Chandler in 1922 opened permanently the following year. The Richard Sparrow House was restored by Strickland & Strickland as a museum, and Plymouth Pottery was opened under the management of Miss Katherine Alden in 1936. The last major tourist attraction to be instituted before 1950 was Plimoth Plantation, Inc., which opened its experimental "First House" near Plymouth Rock in 1949.

Plymouth's commercial activity prevented the town from retaining as quaint an appearance as many Cape Cod or North Shore towns, where poverty had preserved many old buildings. The town kept up to date with new construction and change was a constant factor. In particular, two major "clearances" of downtown neighborhoods swept away many of the picturesque structures: Water Street (1919–20) and the Summer Street–High Street neighborhoods (1964–70). Even with these sacrifices to modernization, however, Plymouth is still admired for its traditional New England appearance.

Nonetheless, the changes do present a difficulty when describing Plymouth's history as so many landmarks of the past have disappeared, leaving only grassy hillsides or modern structures where significant landmarks once stood. For that reason, this guide invites the reader to look beneath the surface to appreciate the fascinating hidden history of New England's oldest town.

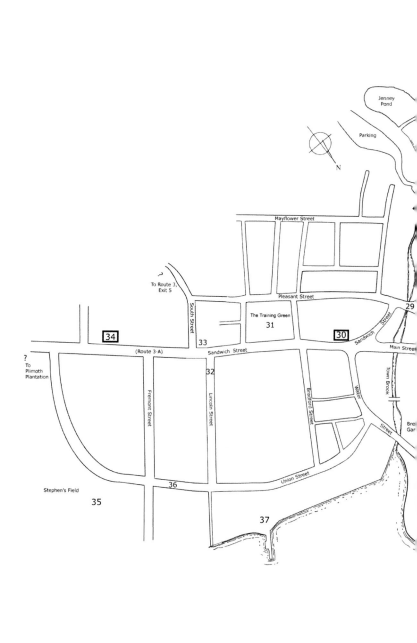

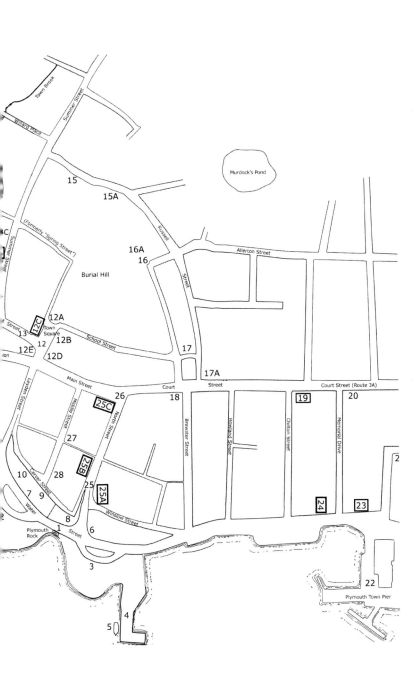

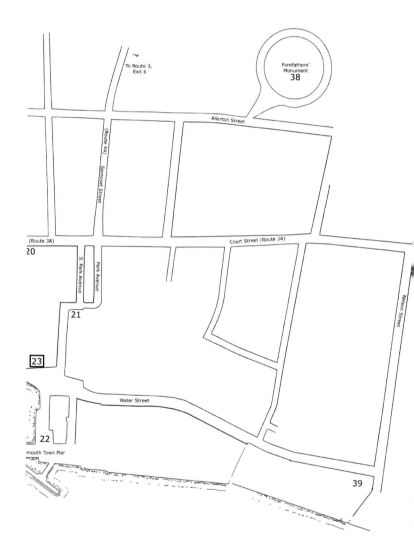

Downtown Plymouth.

Plymouth Walking Tour 1
Town Center

O ur first tour covers the downtown Plymouth area north of Town Brook, where the Pilgrims first established their little village in 1620. Over the centuries the town has grown from those brave first beginnings to a modern community of over fifty thousand inhabitants. When the Pilgrims arrived, they found a narrow strip of fertile farmland along the harbor that had been cultivated for a thousand to fifteen hundred years. Before 1627, when the colonists expanded beyond the original settlement, the fields of New Plymouth extended about three miles from Nelson Street to Eel River. Although modern Plymouth covers an area of over one hundred square miles, for most of the town's history, the population was concentrated in the original village beside Town Brook.

Downtown Plymouth is still a remarkably handsome New England coastal town, with a Main Street (that confusingly changes its name several times within a mile) running parallel to the shore as Route 3A and a waterfront neighborhood that attracts visitors from around the world with its historic significance and contemporary amenities. Court Street/Main Street/Main Street Extension/Sandwich Street is lined with an array of buildings, the variety of which attests to the town's long existence—although none go back to the time of the Pilgrims. Clapboard houses from the eighteenth century stand between dignified brick buildings of the nineteenth century and—because history never stands still in Plymouth—modern shops and stores from the past hundred years. In Shirley Square sturdy linden trees stand in for the elms of yesteryear, while intriguing shops and restaurants can be found, offering visitors and inhabitants alike a diverse shopping experience. Plymouth isn't just about Pilgrims.

The short streets that run between Main Street and the waterfront are graced by some of Plymouth's oldest and most elegant houses. The comprehensive effect of these aged, clustered dwellings, mostly opening directly onto the sidewalk in European village fashion, presents modern visitors with a true, organic, historical community as

it grew over time, which no contemporary development or nostalgic re-creation can possibly achieve. This is not the intellectual history of the first colonists or didactic exhibits in an outdoor museum, but the actual, tangible past—even with the many changes that have taken place since these homes were new. Similarly, the old Main Street that is no longer the commercial heart of the community still displays the artless aesthetic of the authentic community despite the fact that the cultural tide has shifted to malls and official buildings on Long Pond Road, leaving the best of Plymouth's past behind, untouched.

Along Water Street and Plymouth Rock State Park, the actual past is less evident, since the original waterfront was demolished to commemorate the Pilgrims and evoke, not particularly successfully, the "wilderness" that the European settlers saw as their new home. Yet even here, where Plymouth's fishing fleet still comes to make port, or where the fragment of an old foundry looks out over tiny homes that once housed the town's Irish and Italian immigrants, real history breaks through the artificial if well-intentioned efforts to focus solely on Plymouth's most famous forebears.

1: THE STORY OF PLYMOUTH ROCK

There is no more fitting place to begin a tour of Plymouth than where it supposedly all began back in December, 1620—at Plymouth Rock. Sheltered beneath the impressive 1921 portico designed by McKim, Mead and White, the famous boulder rests on the sandy shore within reach of the tide. However, it is not the most self-evident of icons. When some visitors gaze down at Plymouth Rock, all they see is a modest potato-shaped boulder, rather the worse for wear, and hardly an awesome sight. They are aware that this rock is culturally significant—it has been enshrined in a granite temple and millions of Americans and foreigners make pilgrimages to come and gaze upon it—yet they see no obvious reason for this. The rock is not enormous nor it does it glow with an unearthly radiance. It just sits there, so they say, "Is that IT?" and turn away in sorrow or disgust to buy some fried clams or see the animated and entertaining history provided at Plimoth Plantation.

Having failed to prepare for their audience with the rock, they get nothing out of it. They were expecting something perceptibly awe-inspiring and visually overwhelming (the Rock of Gibraltar, perhaps) in accord with the importance of the Pilgrims that was drummed into their little skulls in third grade. Unfortunately they mistake the "accidents" for the "essence," the tangible object for the intangible significance with which it has been invested. The truth is, Plymouth Rock is a symbol and they need to appreciate what it stands for, not what it is.

Plymouth Rock canopy. At sea level beneath the 1921 McKim, Mead & White canopy rests one of America's most celebrated icons, Plymouth Rock, which marks the 1620 Pilgrim landing.

The historical significance of the rock lies in its legendary role as a focus of the Pilgrim story rather than any possible historic employment as a steppingstone. It is a physical symbol of the arrival of the shallop from the *Mayflower* on December 21, 1620, and marks the vicinity where the famed landing took place. Although neither of the two individuals traditionally credited with first setting foot on the rock were actually aboard the shallop on December 11, 1620, either Mary Chilton or John Alden may have trod on the boulder on a subsequent landing. It is not inconceivable that at some point the stone was used as a platform in landing things or people from small craft that could not reach dry land on the very shallow shelving beach, but all that is secondary to its role as a marker of historical memory.

The other question many have is, "is it real—did the Pilgrims actually land on this rock in 1620?" We really don't know. Testimony to the specific place or rather object on which the Forefathers were supposed to have landed in 1620 first surfaced in 1741, with Elder Thomas Faunce's public identification of the famous rock:

About the year 1741, it was represented to Elder Faunce that a wharf was to be erected over the rock, which impressed his mind with deep concern, and excited a strong desire to take a last farewell of the cherished object. He was then 95 years old, and resided three miles from the place. A chair was procured, and the venerable man conveyed to the shore, where a number of the inhabitants had assembled to witness the patriarch's benediction. Having pointed out the rock directly under the bank of Cole's Hill, which his father had assured him was that which had received

*the footsteps of our fathers on their first arrival, and which should be perpetuated to posterity, he bedewed it with his tears, and bid to it an everlasting adieu. These facts were testified to by the late Deacon Spooner, who was then a boy and was present on the interesting occasion...Standing on this rock, therefore, we may fancy a magic power ushering us into the presence of our fathers.**

Plymouth Rock. The world's most famous Dedham granodiorite boulder. The date "1620" was carved into it in 1880 when the two halves were reunited.

There are no seventeenth-century references in the primary sources to corroborate Elder Faunce. The earliest mention of the rock is found in the town records in 1715 where it is noted as a landmark with no mention of any historical association. It is possible, however, that such tales had made an unheralded appearance before this time. Faunce was the third and last elder of the Plymouth church, and his father John had arrived in 1623. He himself was born in 1647 and had known and talked with some of the *Mayflower* passengers. Nothing was recorded about Faunce's attribution at the time, but it persisted in the memories of witnesses, such as Deacon Ephraim Spooner and Mrs. Joanna White, after the 1741 event. The desire for a concrete symbol of the Forefathers was enough to firmly establish the rock in the popular consciousness in the 1770s. With the establishment of Elder Faunce's story of the rock, recounted by Deacon Spooner and first recorded by Edward Winslow Jr. on the Blaskowitz map of Plymouth Harbor (1774) before being enlarged upon in Thatcher's *History of The Town of Plymouth* (1832), the Pilgrim story assumes its modern outlines.

Plymouth Rock's true consecration occurred in 1774, probably as part of the response to the Coercive Acts and the blockading of the Port of Boston.

The inhabitants of the town, animated by the glorious spirit of liberty which pervaded the Province, and mindful of the precious relic of our forefathers, resolved to consecrate the rock on which they landed to the shrine of liberty. Col. Theophilus Cotton, and a large number of inhabitants assembled, with about 20 yoke of oxen, for the purpose of its removal. The rock was elevated from its bed by the means of large screws, and in attempting to mount it on the carriage, it split asunder, without any violence. As no one had observed a flaw, the circumstance

* James Thatcher, *History of the Town of Plymouth, from its First Settlement in 1620, to the Present Time, with a Concise History of the Aborigines of New England, and Their Wars with the English &c* (Boston: Marsh, Capen & Lyon, 1832), 29.

*occasioned some surprise. It is not strange that some of the patriots of the day should be disposed to indulge a little in superstition, when in favor of their good cause. The separation of the rock was construed to be ominous of a division of the British Empire. The question was now to be decided whether both parts should be removed, and being decided in the negative, the bottom part was dropped again into its original bed, where it remains, a few inches above the surface of the earth, at the head of the wharf. The upper portion, weighing many tons, was conveyed to the liberty pole square, front of the meetinghouse, where, we believe, waved over it a flag with the far-famed motto, "Liberty or Death."**

Plymouth Rock became one of the earliest shrines and places of "pilgrimage" for Americans. It served as the symbol of the landing—the birth of Plymouth Colony and, by extension, of New England and the entire nation. The power of the symbol, coupled with the influence of the New England literary establishment, led to the widespread dispersal of the image throughout the United States. De Tocqueville was impressed with the meaning invested in the rock by many Americans:

This Rock became an object of veneration in the United States. I have seen bits of it carefully preserved in several towns of the Union. Does not this sufficiently show that all human power and greatness is in the soul

Town Square—1828 print by Benjamin Parris Bartlett. A man is seating his young son on the upper half of Plymouth Rock, brought up there by Colonel Theophilus Cotton in 1774. The elms were planted in 1784.

* *Ibid.*

*of man? Here is a stone which the feet of a few outcasts pressed for an instant; and the stone becomes famous; it is treasured by a great nation; its very dust is shared as a relic—but what has become of the doorsteps of a thousand palaces? Who troubles himself about them?**

After the war was over, the Rock was neglected to some extent. The upper half was left in Plymouth's Town Square where visitors could not only view but also touch it—and chip bits off. A print of the square by Benjamin Parris Bartlett from 1828 shows a father encouraging his son to sit on the rock and thus experience a spiritual link to the Pilgrims, much as a medieval pilgrim might have touched Thomas à Becket's Canterbury tomb. On July 4, 1834, after generations of souvenir hunters had taken their toll, the rock was moved to a safer location within an iron fence in front of Pilgrim Hall. The lower half remained embedded in the wharf at the original location on the waterfront, where a stone portico designed by Hammatt Billings (who also designed Forefathers' Monument) was erected, a granite structure measuring fifteen square feet by thirty feet high of the Tuscan architectural order completed by 1867. The upper half was reunited with the lower section in 1880. The old portico was torn down in 1920 for the Pilgrim tercentenary celebration and the new canopy, donated by the Colonial Dames of America, dedicated in November 1921.

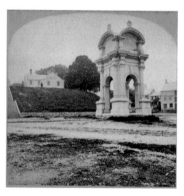

Plymouth Rock portico (1859–1920). Plymouth Rock's first canopy or portico was designed by Hammatt Billings and built over the lower half of the Rock in 1858.

2: Pilgrim Memorial State Park

Plymouth Rock is in the middle of the Commonwealth of Massachusetts's smallest state park. The waterfront area was once a flourishing commercial center where seven wharves and innumerable warehouses, chandleries and workshops served the needs of the seaport from the 1730s until 1920. The ground on which we walk today has been filled to a height of ten feet or so above the original shoreline. In preparation for the 1920–21 tercentenary the old waterfront structures were cleared away to create the park, the first of Plymouth's two major "renewal" projects that dramatically changed the appearance and character of the town. The other was the Plymouth Redevelopment Urban Renewal project (1963–70), which demolished the old Market

* Alexis de Tocqueville, *Democracy in America* (Boston: Ticknor & Fields, 1862), 1:41.

Street/High Street/Summer Street neighborhood, the results of which we will see later on the tour.

Leaving Plymouth Rock, we first turn south to where the Governor William Bradford monument is located. This bronze statue of Plymouth's second and most famous governor was sculpted by Cyrus E. Dallin for the 1920–21 Pilgrim tercentennial as a companion piece to Dallin's other memorial

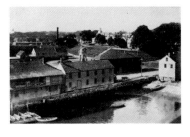

The Plymouth waterfront before 1920. There were seven major wharves and numerous commercial buildings on Water Street at the height of the town's maritime prosperity in the nineteenth century.

to the Wampanoag sachem, Massasoit, on Cole's Hill overlooking the park. However, while the Improved Order of Redmen raised the funds necessary to complete Massasoit's ten-foot-high statue for dedication on September 5, 1921, the Bradford design languished until Thanksgiving 1976. Due to the modern expense of bronze casting, the governor is considerably smaller than Massasoit, "about life size," as was said at the time.

William Bradford (1590–1657) and Massasoit (or Ousamequin, circa 1590-1660) were two of the most important individuals in the history of early Plymouth, serving as the political leaders of their respective communities. Bradford was chosen governor of the colony following the untimely death of Governor John Carver in the spring of 1621, and was reelected almost every year until his death. Bradford was an unusually astute and effective

Governor Bradford Memorial. Bronze statue of Plymouth's Governor William Bradford (1590–1657), by Cyrus E. Dallin (1861–1944).

administrator who guided the little colony through its infancy, ensuring its survival and moderate prosperity. He is also the author of the primary history of Plymouth Colony, *Of Plymouth Plantation*, and the source for much of what we know about the first successful English settlement in New England.

Massasoit, the chief sachem or leader of the indigenous Wampanoag people, governed a federation of autonomous Native American communities in the Plymouth Colony region. When the Pilgrims arrived, his people were recovering from a terrible epidemic that had wiped out entire communities (such as Patuxet, where Plymouth is today). The powerful Narraganset tribe, which had not suffered such losses, was demanding that Massasoit become their vassal and the

Wampanoag territory be subject to their rule. Massasoit instead chose to ally with the Pilgrims and preserve his peoples' independence. After Edward Winslow saved his life in 1622, the Wampanoag leader made a personal commitment to the good relations between the English and the Wampanoag. Together Bradford and Massasoit maintained a sometimes-uneasy peace between the two peoples that lasted over half a century.

3: PLIMOTH PLANTATION SHOPS

Next, we turn and walk north past Plymouth Rock to visit two small "colonial" shops built and managed by Plimoth Plantation. In 1948, the newly incorporated museum built a small thatched building, the "First House," where the smaller shop is today. It was an experimental timber-frame design by architect Charles Strickland based on similar structures by George Francis Dow for Salem's Pioneer Village. The First House was a sample of the re-created dwellings proposed for the Pilgrim Village, and acted as a survey for the feasibility of a future Plimoth Plantation. Its impressive first season success in 1949, when it attracted over 310,000 visitors, greatly advanced the plantation plan. The present shop replaced the First House in 1991. Behind the smaller shop is the "1627 House," built in 1955 as a museum shop, which is the only surviving example of an original Strickland "Pilgrim" house.

4: STATE PIER

Mayflower II is moored at the James Frazier State Pier. The pier is also the location of the Plymouth to Provincetown Express Ferry and the *Pilgrim Belle* harbor cruise. The Ferry follows the twenty-six-mile route of the *Mayflower* to where the Pilgrims first landed and spent a month exploring the coast before settling at Plymouth, a seventy-seven-mile drive by land. From May through October, weather permitting, the *Pilgrim Belle* offers an hour-and-a-quarter-long tour of Plymouth Harbor, passing by Plymouth Beach, Clark's Island and the Gurnet Point Lighthouse. There are also special Sunday-brunch and sunset cruises in season.

5: *MAYFLOWER II*

Leaving Plimoth Plantation's waterfront shops we see *Mayflower II*, the museum's impressive full-scale reproduction of the 1620 vessel, moored at the James T. Frazier State Pier. *Mayflower II* was built in the Upham Shipyard at Brixham, Devonshire in England between 1955 and 1957, using plans developed for Plimoth Plantation by noted

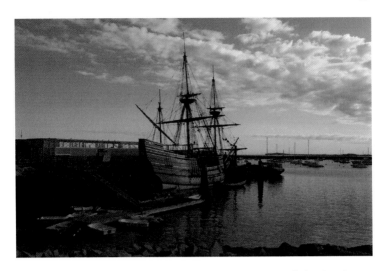

Mayflower II, Frazier State Pier. *Mayflower II*, built in England and sailed to America in 1957, is exhibited by Plimoth Plantation, Inc., and after fifty years, still sails on occasion.

marine architectural historian William Avery Baker. The ship was the brainchild of Warwick Charlton, an English advertising executive. He founded Project Mayflower, Ltd. in 1954 to create a tangible memorial to the traditional Anglo-American alliance that had proved so vital during World War II. A stickler for quality, Charlton made sure that the re-created vessel would be as accurate a representation of the original *Mayflower* as possible. Built from English oak (and some Douglas fir), with true Italian hemp line for the rigging and real flaxen canvas woven in Scotland for the sails, the little ship was a labor of love for all those involved in its construction and the voyage to America.

Mayflower II left England on April 20, 1957, under the command of Captain Alan Villiers, a celebrated master of square-rigged vessels, with a volunteer crew of twenty-nine men and three media representatives. There was no escort vessel or auxiliary engine, and except for a modern ship's wheel, radio and a small generator, the fifty-five-day voyage was made entirely under sail using the ship's seventeenth-century technology. Becalmed at times and buffeted by storms off Cape Hatteras, the little ship made landfall at Provincetown, Massachusetts, on June 12 and arrived in Plymouth on June 13, 1957. Following a year of visits along the Atlantic Coast from New York to Florida, *Mayflower II* returned to its permanent berth in Plymouth in the autumn of 1958.

Today, visitors are able to go aboard the vessel during Plimoth Plantation's open season (the last Saturday in March to Thanksgiving weekend) and talk with costumed reenactors and contemporary museum interpreters who ably inform them about both the 1620 and 1957 voyages. The three-masted *Mayflower II* is a small ship by

today's standards: 181 tons burden (236 tons displacement), 106½ feet long, with a beam of 25½ feet and a draft of 13 feet. An authentic environment is an integral part of the *Mayflower II* experience. Plimoth Plantation goes to great lengths to re-create to the furthest extent the details of seventeenth-century life. Furnishings, clothing and everyday utensils are reproductions of objects produced during the period. Although not a naval vessel, *Mayflower* did carry several cannon in the 'tween decks area for defense. It was there that most of the 102 passengers were housed on the 1620 voyage in small "cabbins" built along the sides of the ship. Their personal possessions, except for the minimum needed for daily existence, were stowed below in the hold with the ship's stores until they were brought ashore at Plymouth.

Moored beside *Mayflower II* is the thirty-three-foot, four-ton "Mayflower Shallop." A reproduction of the workboat that was brought in pieces by the Pilgrims in 1620 and put together on the beach at Cape Cod Harbor (today's Provincetown), the Mayflower Shallop was built at Plymouth Marine Railways in 1957 from W.A. Baker's plans, so that it might greet *Mayflower II*. Completing the "set," a twenty-one-foot ship's boat, or longboat, typical of the work boats carried aboard ships of the *Mayflower's* size, was reconstructed from the Baker plans by Peter Arenstam at Plimoth Plantation in 1991. *Mayflower II* and the accompanying Dockside Exhibit are open from 9:00 a.m. to 5:00 p.m. during the Plimoth Plantation season (see above).

There is a good set of public restrooms in a pseudo-colonial structure near the pier. On the west side of Water Street are souvenir shops and fast food restaurants. Crossing over just before the junction with North Street, we come to a small garden area and the Women of the Mayflower (popularly, the "Pilgrim Mother") fountain.

Memorial to the Pilgrim women. Donated by the Daughters of the American Revolution in 1925 and designed by McKim, Mead & White with a demure statue by C. Paul Jennewein (1890–1978).

6: WOMEN OF THE MAYFLOWER FOUNTAIN

The memorial fountain designed by McKim and White for the 1920 tercentenary displays an austere "Pilgrim Mother" statue by Paul Jennewein that contrasts curiously with the robust "Pilgrim Maiden" bronze in Brewster Gardens (Tour 3).

7: COLE'S HILL

Crossing North Street we walk south beside the grassy bank of Cole's Hill until we reach the flight of granite steps leading to the hilltop. Where the faux-Georgian condominium building sits today on the northeast corner of the hill, John Cole, who gave the hill his name, built a house in 1697. Cannon were installed in earthworks on Cole's Hill in 1742, during the Revolution and again in 1814 for protection of the town. During the eighteenth century, there was a continuous line of buildings and granite terraces set into the hillside along Water Street from North Street to Leyden Street. Shipping became less prosperous in the mid-nineteenth century, and the Pilgrim Society (founded in 1820) was able to buy and remove eight of the old commercial establishments to create the smooth slope and stairway as the start of the present park in 1856. South of the steps, another eight warehouses, shops and dwellings survived until a bequest to the Pilgrim Society by J. Henry Stickney of Philadelphia in 1893 provided the funding necessary to complete the slope all the way to Leyden Street, which was done by about 1911.

The 1809 "Bridal Tree." The ancient linden tree as it appears today on the northeast corner of Cole's Hill.

8: THE BRIDAL TREE

Ascending the steps, we come to the top of the hill. To our left are the sadly diminished remains of Plymouth's "Bridal Tree," an ancient linden tree that had been planted in a nearby yard by a young couple on their engagement in 1809. However, the marriage never took place, and the young woman in question pulled the sapling up and threw it in the road. It was found by William Davis, who lived on the hill, and he dug a hole with his heel and stuck it in. Surprisingly, it survived and was for many years a local landmark of majestic proportions.

9: MASSASOIT STATUE

To our right is Cyrus Dallin's imposing 1921 memorial to Massasoit, the Native sachem who befriended and protected the Pilgrims in their early tenuous years. Nearby is a small plaque bearing a more modern Native American sentiment concerning the Pilgrims that, despite historically dubious assertions concerning "genocide," reflects another view of the colonial story. Native American spokespersons have gathered here around Massasoit's monument each Thanksgiving since 1970 to observe a "day of mourning" reflecting their perspective of the course of American history symbolically set in motion by the Pilgrims.

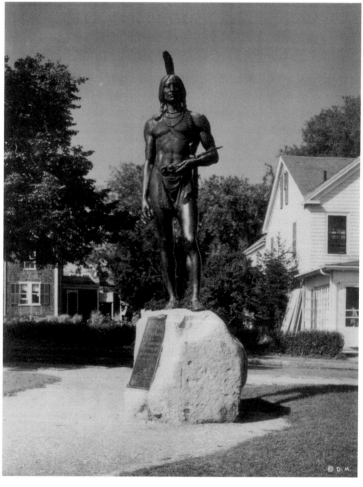

Massasoit. Bronze statue of Wampanoag sachem Massasoit, or Ousamequin (circa 1580–1661), by Cyrus E. Dallin (1861–1944).

10: PILGRIM SARCOPHAGUS

Further south along Carver Street (which runs along the top of the hill and is named for Plymouth's first governor, John Carver, who died in the spring of 1621) is a large granite sarcophagus containing some Pilgrim remains found nearby during the digging of sewer lines in 1855 and 1883. This is where, by a tradition transmitted by Elder Faunce, the *Mayflower* passengers buried nearly half of their unfortunate company (half the crew died as well) in the terrible winter of 1620–21. It was done, he said, under cover of darkness and then sowed with crops to hide the depletion of the little company from the Indians. Whether the deception was actually carried out as reported or not, burials (including that of Carver) were made on this spot. According to Plymouth historian William T. Davis, burials continued to be made here until 1637. The first rediscovery of the bones occurred during a heavy rain or "freshet" in 1735, which washed many of the remains down the hill and into the harbor. When more skeletons were uncovered, they were sent to Boston to see if they were European or Native. Pronounced European by Dr. Oliver Wendell Holmes Sr., four skeletons were returned to Plymouth and placed in a lead-lined casket in the top of the old Hammatt Billings canopy over Plymouth Rock in 1867. The casket was retrieved when the old canopy was torn down, and it was interred in the present memorial on May 24, 1921.

Continuing along Carver Street, we come parallel with Leyden Street, which dips sharply down to Water Street. We can look down at the entrance to the Brewster Gardens Park and see a brick-ended house built in the 1790s by Joseph Tribble that stands just west of where the original "Common House" and storehouse were built in the winter of 1620, only to be burned down by roistering sailors on November 5, 1624. Some artifacts were discovered in 1801 while a cellar was being excavated on the site. Just before we join Leyden Street, there is a small alley on the right called LeBaron's Alley, which is of ancient vintage. It continues across Middle Street via Spooner's Alley, and across North Street as Gordon Place. Alleys of this sort are a particular feature of old New England seaports for some reason.

11: LEYDEN STREET ("FIRST STREET")

Leyden Street—formerly "First Street" or just "The Street"—is named for the Dutch city of Leiden where the Pilgrim congregation found refuge in 1609. Leyden Street is where the Pilgrims began building their houses in the winter of 1620–21, and it has been the heart of the town ever since. Running from the harbor side at its eastern foot to the eminence of Burial Hill on the west, Leyden Street (including Town Square) is the oldest continuously occupied street in British North America. The "Pilgrim Village" at Plimoth Plantation re-creates this

Leyden Street. Plymouth's "First Street" on which construction began days before Christmas, 1620. Whereas Jamestown was later abandoned, people still live on Plymouth's first street today.

thoroughfare as it was in the year 1627, just before families began to move out to individual farms north and south of Plymouth Village.

Leyden Street east of the Main Street intersection is an assortment of eighteenth- and nineteenth-century houses that front directly onto the sidewalks. They stand close together on small lots that date to colonial times. The lots on the south side are still roughly 49½ feet deep, as was allotted in the first division in December 1620. None of the early seventeenth-century structures survive, however. The last of the Pilgrim homes vanished generations ago when the Hickes or Alleyn House (1639) was torn down in 1822. It stood where a small garage is today between 6 and 2 Carver Street. A Universalist church built here in 1822 burned down in the 1930s and the garage was erected.

Just where the other first houses were located is something of a historical puzzle. The lots on the north side of the street survived long enough to be recorded in deeds (although some were modified and combined by the time they enter the written record), but those on the south side below Main Street Extension were combined into a single property by 1637. A map of the proposed division of the south side of the street survives from 1620, but whether it was acted upon without change is unknown. The Winslow House, for example, is located west of Market Street on the map, but as the oldest surviving house in 1698, the Winslow House was located where 17 Leyden Street passes just *east* of the old post office today. The house located there now was built by General Nathaniel Goodwin in 1807.

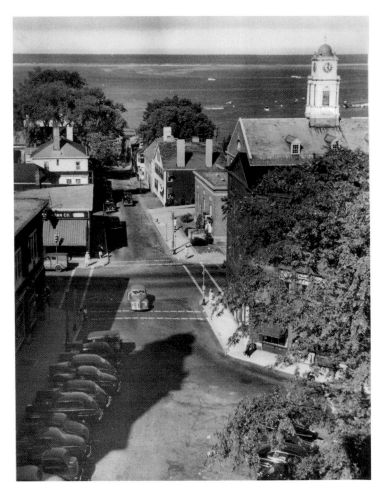

Leyden Street, circa 1940. Looking down Leyden Street from above Town Square. Most of the earliest houses were in the area shown here.

The lots on the south side of the street listed on the 1620 map (proceeding from east to west) are: "Peeter Brown, John Goodman, Mr. Brewster, 'high way' [the cross street], John Billington, Mr. Isaak Alerton, Francis Cooke, Edward Winslow." There is no way to precisely locate any of these assignments but they have been traditionally projected onto the existing lots both in markers placed on several buildings and in the re-created 1627 street at Plimoth Plantation. The arbitrary nature of this placement is illustrated by the adjustments made when the "Plympton house" (which stood where Main Street Extension was cut through in 1907–08) was torn down, and the Brewster location was assigned to the new 1915 post office building. The fact that the original cross street had been Market Street was conveniently forgotten. Where the former post office building sits today, a house once stood that was

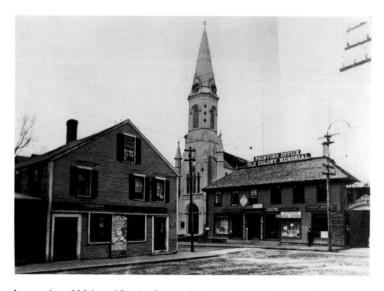

Intersection of Main and Leyden Streets, circa 1890. Main Street Extension was put through the Old Colony Memorial offices in 1907, and the Baptist Church replaced by the present post office building.

built in 1703 by Dr. Francis LeBaron and immortalized by Jane G. Austin in *The Nameless Nobleman* (1881). The house was succeeded by the Plymouth Baptist Church in 1865.

Proceeding along the north side of the street from Carver Street, the first documented lot we come to is the old parsonage or Samuel Fuller lot that extended from the Hickes lot (across the alley) to include 18 Leyden Street— a well-worn sign identifying the Fuller ownership can be seen. These lots extended to Middle Street to the north. As this lot is considerably wider than a standard 1621 division property, we assume it incorporated some lots whose ownership reverted to the town after the original grantees died or moved away. Samuel's widow, Bridget Fuller, and her son Samuel left the land to the Plymouth church in 1664. The next Pilgrim lot is that of John Howland, whose ownership is indicated by a small cement sign set into the sidewalk in front of 16 Leyden Street. The lot on the corner of Main Street (called "the Highway" in early records) belonged to Stephen Hopkins. We now cross Main Street and enter Town Square at the top of Leyden Street.

12: TOWN SQUARE

Plymouth differs from many New England towns in having a market square rather than a green at its center. Standing on the traffic island in the square, we can look west toward the First Parish Church and Burial

Town Square. The 1749 Courthouse and the stone First Parish Church (Unitarian), built in 1898. The white wooden Church of the Pilgrimage (Congregational), built in 1840, is hidden on the right.

Hill beyond. To our right and south is Market Street, the original path south across Town Brook (hidden in its narrow valley) leading toward Watson's Hill, where the Plymouth colonists first met the Wampanoag sachem Massasoit. The cross street was originally offset so that Main Street enters the square farther east than Market Street. Today, Main Street Extension continues directly across the brook to join Sandwich Street heading south, but until 1908 all traffic, including the electric streetcars, turned right and crossed Market Street Bridge. With the exception of the 1749 Courthouse, Market Street's stores, houses and mills were all demolished by 1970 to make way for new stores, parking lots and an interchange with Summer Street.

Town Square occupies the upper end of Leyden Street and is surrounded by public buildings on three sides. The 1749 Courthouse on the corner of Market Street occupies the south side of the square; the stone First Parish Church (Unitarian) is at the west end; and the white wooden Church of the Pilgrimage (Congregational) is on the north side. The brick "Bradford Building" (1905) extends from the church to the corner of Main Street. A stairway up Burial Hill can be found at the northwest corner of Town Square at the entrance to School Street.

12A: FIRST PARISH CHURCH (UNITARIAN)

Plymouth's first meetinghouse was the ground floor of the fort built in 1622 behind the present stone church on the southwestern spur of Burial Hill. An oval, marble marker indicates the fort/meetinghouse site on top of the hill. In 1648, a new meetinghouse was built on the north side of Town Square facing Market Street, occupying part of the Church of the Pilgrimage lot and the westerly end of the Bradford Building site. This was replaced in 1683 by a new building in the square east of the present church. The meetinghouse was renewed in 1744 and 1831. The current granite Romanesque building was dedicated in 1899, replacing the 1831 Gothic wooden church that burned down in 1892. It is the fourth meetinghouse to be located at the head of the square.

12B: CHURCH OF THE PILGRIMAGE (CONGREGATIONAL)

Plymouth's third church separated from the First Parish Church in 1801. As with an earlier temporary division during the Great Awakening in 1744, the more conservative members of the church chose to leave and establish their own Calvinist congregation rather than accept changes supported by the majority that resulted in the adoption of Unitarianism. Their first meetinghouse was located south of Town Brook above the Training Green, but in 1840, the third church returned to Town Square and moved into this new church building.

12C: 1749 COURTHOUSE

This simple wooden structure replaced the earlier "Country House" that had been the seat of Plymouth Colony government before the "Old Colony" was swallowed up by Massachusetts Bay in 1692. Designed (by tradition) by Judge Peter Oliver of Middleboro, the courthouse served Plymouth County's circuit court and was also the seat of Plymouth's town government. The courtroom was located on the second floor with offices on the first floor, and there was a public market on the basement level until 1858. The town's first fire engine, acquired in 1829, was also stored in the basement (and is still on view there today). After the new county courthouse was built on Court Street in 1820, it became the Plymouth "Town House." Spared in the urban renewal of the 1960s, the oldest wooden courthouse in America was turned into a town museum in 1970. A re-creation of a colonial courtroom was

Plymouth Town House, circa 1900. The 1749 Courthouse, subsequently the seat of town government from 1820 to 1953, is now a town museum. There was a market beneath the building years ago.

installed on the second floor and artifacts from Plymouth's past put on display where the town offices were located until 1953. The 1749 Courthouse is open to the public from June through Columbus Day (and Thanksgiving) between 11:00 a.m. and 5:00 p.m. Admission is free.

12D: THE BRADFORD BUILDING

This 1904 building occupies the lot owned by Governor William Bradford (1590–1657) and later his son Major William Bradford, as well as a portion of the land inherited by his other son, Joseph Bradford. It was later the location of the Plymouth post office and the Odd Fellows' Hall (1876–1904), which burned down and was replaced by the present building.

12E: THE DREW BUILDING

Until the 1840s, the eastern corner of Market Street and Town Square was occupied by the Shurtleff House (1689). The old house was moved south and later demolished. The westerly end of the present brick building was built in 1883 and the easterly section added after Main Street Extension was opened in 1908.

From Town Square we can continue south along Market Street (Tour 1) or visit Burial Hill (Tour 2).

13: MARKET STREET

This area of downtown Plymouth has changed so dramatically over the past half-century that it is almost as difficult to describe what it looked like in 1950 as it is to imagine its appearance in Pilgrim times. Crossing onto the sidewalk at the corner of the 1749 Courthouse, we come to a granite milestone bearing the distances to Provincetown (seventy-seven miles) and to Boston (forthy-five miles). The milestone marks the spot where Plymouth's liberty pole was erected before the American Revolution. The upper half of Plymouth Rock was also located here from 1774 to 1834 (see the history of the rock at the beginning of this tour). Proceeding south along Market Street, we stop at the southerly end of the small parking lot on our right. This is approximately where the south gate in the palisade wall surrounding Plymouth Village once stood. In 1622, the Plymouth colonists erected an eight-foot-high

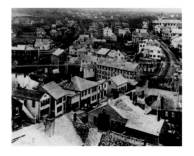

Market Street, circa 1870. A view of Market Street from the First Parish Church steeple, with Pleasant Street to the right and Sandwich Street to the left.

palisade (split-log defensive barrier) around their settlement, with gates at the north, south and eastern corners. By 1630, a few homes had been built outside the walls. The Nathaniel Morton and Experience Mitchell Houses were on the east side of Market Street and others were located along what is now Summer Street.

Over the next two centuries, the Market Street–Summer Street neighborhood grew and prospered to become one of Plymouth's prime residential centers. Houses from the seventeenth to the nineteenth centuries rubbed shoulders in the picturesque diversity that characterizes old New England seaports. Unfortunately, the old neighborhood became poor and rundown in the early twentieth century, and the town turned to "urban renewal" as a solution to the problem. Although a few old structures were saved, over a hundred houses dating from the 1680s to the 1890s were torn down. Forty homes (including the seventeenth-century Barrows/Leach House) were demolished in the mid-1960s to construct the John Carver Inn alone.

Where the small parking lot to our right is now, a residential street called High Street was opened in 1794 over the hill to the west, virtually all traces of which disappeared during urban renewal. Similarly Market Street was once a crowded and vibrant commercial area where today there is only a 1960s brick building across the street that houses a Dunkin' Donuts and Tedeschi's Market. Plymouth's first jail, a wooden two-story structure built in 1641, was located at the present entrance to the John Carver Inn parking lot. Continuing south, we cross the Summer Street intersection to the Market Street Bridge. There have been three bridges built here over the old ford ("the Wading Place") from the 1660s until now. In Pilgrim times, "Spring Hill" above the bridge was so steep that it had to be approached by a slanting path down to the brook starting from about where the westerly end of the wooden hilltop fence is today. A similar diagonal path on the south side of the brook led up to where Sandwich Street turns south. We now look down a long grassy slope to Town Brook where a small bridge and an ancient granite horse trough stands, marking the site of the town's second gristmill, which was still grinding grain as late as the 1920s. The small rapids here may have been the source of Plymouth's Indian name of "Patuxet" ("the little falls"), or the source may have been the rapids located where the dam (built in the 1630s) and the re-created Jenney Grist Mill are just upstream. A string of parks and paths now line the brook from its mouth almost to its source at "Billington Sea," a mile to the west where the original Patuxet Indian settlement was apparently located. We will trace this route on Tour 3.

14: SUMMER STREET

Summer Street follows the original Wampanoag Indian Nemasket Path west until it reaches Newfield Street. Turning right, we follow the

wooden fence to the Bishop House, which was one of four structures preserved by being moved during urban renewal in the mid-1960s. The north side of Summer Street was completely cleared of buildings and the street was considerably widened. Senator Edward Kennedy and others raised funds to move the house from the north side of the street to its present location.

14A: THE JOHN BISHOP HOUSE (CIRCA 1789)

This building was originally on the westerly corner of Spring Street (now just a narrow paved path extending from Summer Street up to Burial Hill at the west end of the John Carver Inn parking lot). It was moved to its present site during the renewal project. It is a fine Federalist structure with brick ends.

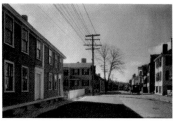

Summer Street, circa 1925. Most of these houses were torn down during the 1960s urban renewal project. The Sparrow House, not yet "restored," is to the left of the elm tree.

The next house (still in its original location) was built by William Sherman circa 1792. We then come to one of the oldest extant houses in Plymouth, although probably not as old as the traditional date of 1640 would have it.

14B: THE SPARROW HOUSE (CIRCA 1640/1680)

The Sparrow House was restored in the 1930s by Sidney and Charles Strickland and identified as the oldest house in Plymouth on the basis of land ownership by Jonathan and Pandora Sparrow, who acquired the property before 1636. Together with the eighteenth-century addition on the west side, the old house became Plymouth Pottery in 1932 under the direction of Miss Katherine Alden. Today Miss Lois Atherton, who manages the house and a fine gift shop of unusual and high quality art and craft items, ably carries on that

The John Bishop House. Built about 1800, the house was saved by being moved from the north side of the street during urban renewal. It is the dark-colored house next to the right-hand car in the previous picture.

The Sparrow House. The left side of the house dates to the seventeenth century, when it was built by George Bonum on land owned by Richard Sparrow in 1641. It is now a museum and crafts shop.

tradition. The Sparrow House is open daily (except Wednesdays) from 10:00 a.m. to 5:00 p.m.

The subsequent house was also built in the seventeenth century and is still a private home today.

14C: THE NATHANIEL CHURCH HOUSE (CIRCA 1684)

Church became the owner of the Jenney Grist Mill in 1684 and built this house. The house on the corner of Spring Lane, which leads down to the Jenney Grist Mill (see Town Brook Tour 3) re-creation and Jenney Pond Park, was built by Sylvanus Bartlett circa 1748. From here west along Summer Street to Willard Place there are a number of older houses (thinned out somewhat during the renewal project) in their original positions, although farther from the sidewalk than they were originally located. The two houses between Willard Place and Newfield Street, however, were both moved from the north side of the street.

Newfield Street was where the old Nemasket Path crossed to the south bank of the brook and joined the Agawam Path. The Samuel W. Holmes playground and skateboard park on the west side of Newfield Street occupies the site of an early ironworks, a rolling and slitting mill that utilized deposits of bog iron in the region to make nails and sheet iron from 1792 to 1897. The old dam west of the ironworks broke on September 24, 1906, and destroyed the abandoned factory. Just above the dam is the Long House, built about 1800 by Martin Brimmer who established the ironworks. It is of historic interest as the birthplace of Oliver Ames Jr., projector and president of the Union Pacific Railroad when the famous "golden spike" was driven May 10, 1869, at Promontory, Utah.

15: RUSSELL STREET

Running under the housing development across from the playground through a culvert, which empties into Town Brook just east of the Newfield Street bridge is a small stream called "Prison Brook." It marked the western boundary of the old Market Street jail "liberty," an area in which debtors and other non-violent inmates were free to go about in during their term of imprisonment. We will now cross Summer Street and follow the boundary up Russell Street. The entrance to Russell Street (or more correctly, the former High Street) used to join Summer Street just across from Willard Place, but it was moved east during urban renewal. Ascending the hill we come to where Russell Street now joins the old street line at the Ryder Home, the only surviving structure on High Street.

15A: THE RYDER HOME

Built by Job Rider circa 1810, the Ryder Home was made into an assisted-living facility for indigent old Plymoutheans under the will of Miss Rebecca Ryder, who died in 1890. Furnished rooms for eight "members of the family" were prepared and six elderly ladies admitted. A matron originally cared for the residents, and since then many elderly ladies (and four gentlemen) have had their last days made more comfortable through this old-fashioned private charity.

Standing in front of the Ryder Home and looking east, we can see the direction in which High Street ran toward Market Street on the other side of the hill. Continuing up Russell Street (which was laid out in 1833), we pass by a short dead-end street called Stoddard Street, which leads to Murdock's Pond, a small hidden "kettle hole" pond named after John Murdock before 1700. The way to the pond was called "Ring Lane" in the 1630s.

The Ryder Home. This 1810 house became Plymouth's sanctuary for poor gentlefolk in 1890. It is the only surviving house on High Street, once a fashionable address but in later years, sadly decayed.

16: BURIAL HILL—NORTH ENTRANCE

We come to the intersection with Allerton Street at the crest of the hill. To our right are a small parking lot (where the old Burton school once stood) and the north entrance to Burial Hill. Because the path at this end has no stairs and there is convenient parking, this is the best way for visitors with limited mobility to access the ancient graveyard. On a small mound to the right of the entrance to Burial Hill, there is a reproduction of the round, brick, eighteenth-century "powder house," where gunpowder was safely stored at the time of the American Revolution.

Burial Hill and the Powder House. The north entrance to Burial Hill, with the re-created 1777 brick gunpowder storage facility.

16A: THE POWDER HOUSE

The original structure was erected in 1770 when it became evident that invasion might occur and the town would need considerable amounts of gunpowder for both cannon and muskets. The dilapidated structure was torn down in 1880, and the present building was dedicated by

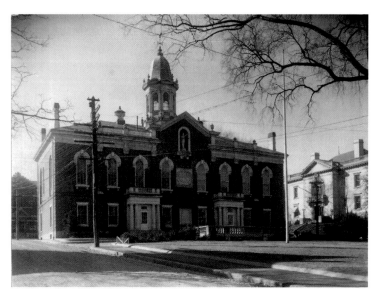

1820 Plymouth County Court House. Location of the Plymouth County Court from 1820 to 2007, the courthouse is one of the town's significant architectural treasures.

the Massachusetts Sons of the American Revolution on October 12, 1920. For other Burial Hill features, please consult Tour 2.

17: 1820 COURTHOUSE & COURT SQUARE

Continuing east down Russell Street to the intersection with Court Street, we come to a number of brick buildings and a small green. The building directly behind the green is Plymouth's 1820 courthouse, considered an architectural gem in its day (it was enlarged and remodeled in 1857, 1881 and 1962) and serving as a tourist attraction throughout the nineteenth century. It has served the Plymouth District Court for over 185 years, but now a new, modern $71 million courthouse scheduled to open in 2007 is being constructed on Obery Street a mile or so to the south. Like the 1904 Registry of Deeds building across Russell Street, the old courthouse is incapable of meeting modern needs. The registry moved to *its* new home on Obery Street in 2005.

Behind the courthouse extension to the west is the former house of correction, built in 1884 of brick with granite trim. By 1911, the jail had become inadequate and the prisoners were moved to a new county farm and jail on Obery Street, which was in turn superseded by the new Plymouth County Correctional Facility on Long Pond Road in 1994. The Obery Street County Farm property became the site of the new court and registry. The 1884 building houses the Plymouth County Law Library, where the original Plymouth Colony

The Bartlett-Russell-Hedge House, circa 1960. This elegant Federalist home, built about 1803, has served as a bank for decades.

records are stored, and the offices of the county commissioners, but they too are moving to Obery Street. The future disposition of these county properties is now under intense discussion, and it is hoped the historical importance of the 1820 courthouse is recognized.

On the north corner of Russell and Court Streets is one of Plymouth's most elegant Federalist buildings and one that is on the National Register of Historic Places.

17A: THE BARTLETT-RUSSELL-HEDGE HOUSE

Built by Joseph Bartlett in 1803, this house was the childhood home of John Bartlett of *Bartlett's Quotations*. Occupied for many years by the Russell and Hedge families, it is today the southern end of the Sovereign Bank building. Across Court Street from Court Square is Brewster Street (laid out in 1884), which leads down to the waterfront. On the south corner is the Old Colony Club of Plymouth, originally founded in 1769 and one of the town's most historic institutions.

18: THE OLD COLONY CLUB

In January 1769, a group of seven young Plymouth men—Isaac Lothrop, Pelham Winslow, Thomas Lothrop, Elkanah Cushman, John Thomas, Edward Winslow Jr. and John Watson—met together to form a club, probably after the developing London model, that

would avoid "the many disadvantages and inconveniences that arise from intermixing with the company at the taverns in this town of Plymouth." They then established the Old Colony Club. In December, they decided to hold their annual meeting on the anniversary of the landing on Plymouth Rock. This celebration, originally referred to as "Old Colony Day" and later as "Forefathers' Day," was first observed on December 22, 1769. The use of the term "Pilgrims" to refer to the Plymouth colonists had not yet come into use. They were still just the local forefathers of the little community rather than the symbolic progenitors of the whole nation.

Old Colony Club, 1920. After renting rooms for many years, the Old Colony Club acquired this permanent "clubhouse" in 1893. It consists of two eighteenth-century houses joined together.

The December 22 date was chosen to adjust to the discrepancy between the Julian or Old Style and the Gregorian or New Style calendars. When England and the colonies finally did accept the new system in 1752, eleven days had to be added to make the adjustment. With that recent event in mind, the Old Colony Club converted the landing anniversary to December 22. Unfortunately, it was only necessary to add *ten* days to adjust a date for the early seventeenth century, since the two calendars had not yet diverged by eleven days. This resulted in odd juxtapositions in later history books where the Forefathers would arrive at Cape Cod and sign the Mayflower Compact on (Old Style) November 11, but make their famous landing on (New Style) December 22, 1620!

On the morning of the said day (Dec. 22, 1769), after discharging a cannon, was hoisted upon the hall [Old Colony Hall, which once stood on Market Street south of the 1749 Courthouse,] an elegant silk flag, with the following inscription, 'OLD COLONY, 1620'…At half after two a decent repast was served, which consisted of the following dishes, viz.

1, a large baked Indian whortleberry pudding;

2, a dish of sauquetash [succotash];

3, a dish of clams;

4, a dish of oysters and a dish of codfish;

5, a haunch of venison, roasted by the first Jack brought to the colony;

6, a dish of seafowl;

7, a dish of frost fish and eels;

8, an apple pie;

9, a course of cranberry tarts, and cheese made in the Old Colony."[*]

By creating a specific anniversary for the landing of the shallop at Plymouth Rock (not the *Mayflower*, which only arrived in Plymouth Harbor on December 16), the club defined it as the pivotal event in the Forefathers' story and provided a focus for much of the Pilgrim symbolism that was to follow. Later members included Alexander Scammell who died as a general at Yorktown. The club disbanded in 1774 over the approaching Revolution when the Tory and Patriot members disagreed.

The next chapter in the history of the club begins in 1875. Several prominent Plymouth men met at Pilgrim Hall on April 15 to draw up a constitution for a revival of the Old Colony Club. They also revived the traditional Forefathers' Day celebration with the ritual consumption of "Plymouth Succotash," which is made with corned beef, fowl, salt pork, beans, whole hominy, turnip and potatoes. The club acquired its present clubhouse in 1893. Today the club marches in civic parades (always wearing top hats) and observes Forefathers' Day with a dawn march led by a small band to Cole's Hill to fire a cannon in honor of the landing, followed by the traditional succotash dinner in the evening. The former Methodist Church on the north corner was built in 1886 and is now the Congregation Beth Jacob Community Center.

Turning left at the Bartlett-Russell-Hedge House, we continue north on Court Street. Across the street on the east side is where the Pilgrims had their first fields. The 1623 land division of planting fields extended east of Court Street from North Street to Nelson Street. The fields were long and narrow, extending down to the harbor. Beyond North Street, two one-acre lots were assigned to William Bradford, followed by assignments (not all of known extent) to Edward Winslow (four acres), Richard Warren, John Goodman, John Crackston, John

[*] Thatcher, *History of the Town of Plymouth*, 181.

Alden, Mary Chilton, Myles Standish (two acres), Francis Eaton (four acres), Henry Sampson (one acre) and Humility Cooper (one acre) to just beyond the Route 44 intersection. By 1637, all of the land before Chilton Street and Pilgrim Hall belonged to Governor Bradford and the rest to Edward Winslow. If we were walking along "the Highway" in Pilgrim days, we could look down the slope to the harbor across planted cornfields. In the nineteenth century there was no Water Street at the foot of the slope, but there were small ropewalks, and in the 1850s, a gas works.

The west side of the street as far as Samoset Street (Route 44) was reserved by the town until after 1700. There are some early eighteenth-century timber frames in the houses along here, but the structures have been so modified over time that it is difficult to perceive any elements that date back to the colonial period. For example, 46 Court Street was apparently built in 1721, number 58 in 1781 and number 69 in 1780. The key is to look above the present storefronts.

The first house of note on the east side of the street, 58 Court Street (marked with a small plaque over its door) was built by Isaac Symmes in 1772, and later occupied by Plymouth's most famous "dame schoolmistress," Tabitha Plasket (1743–1807). When this house was a tearoom in the 1920s, it was featured in guidebooks and on postcards, but it has largely been forgotten today. Next we come to Pilgrim Hall (75 Court Street).

19: PILGRIM HALL

Plymouth's original historical museum, Pilgrim Hall, is the oldest public museum in the United States. It is a granite Greek Revival building built in 1824 to the designs of noted architect, Alexander Parris (1780–1852), who also designed Boston's famous Quincy Market. The Pilgrim Society was founded in 1820 and built the hall as a meeting place for the society and as a repository for historical collections associated with Plymouth and the Pilgrims. It has the world's largest collection of authentic Pilgrim and *Mayflower* artifacts, including a rich gathering of art illustrating the Pilgrim story, as well as other irreplaceable objects from Plymouth's long history. Here you can see Myles Standish's sword, William Bradford's silver cup, John Alden's Bible, books illicitly printed by William Brewster in Leiden, the wicker cradle William and Susanna White brought from Holland for their expected child (Peregrine, a boy, born aboard the *Mayflower* in Cape Cod harbor in December 1620) and several "great chairs" associated with Pilgrim leaders.

Although not constructed in time for Daniel Webster's acclaimed 1820 Forefathers' Day address (which was delivered in the new 1820 courthouse), Pilgrim Hall has been the center of Plymouth historical interest and activity for almost two hundred years. Balls and dinners

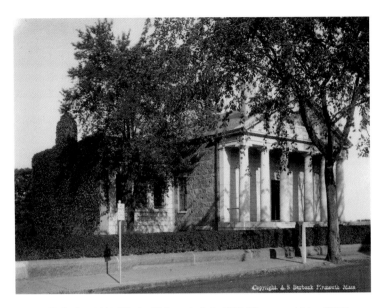

Pilgrim Hall, circa 1930. Pilgrim Hall was built in 1824. The new addition (2007) was installed in front of the 1904 library wing, which is covered with Virginia creeper in this photo.

with speeches extolling the example of the Pilgrims have entertained Plymoutheans and visitors in the spacious upper hall. Exhibits of both Native American and Anglo-American culture and a large chunk of Plymouth Rock you can actually touch have also found their way here. The original 1621 colonial patent or charter for Plymouth Colony can be seen in the lower hall, as can the 1651 portrait of Edward Winslow, the only likeness of a Pilgrim taken from life. There is even a real "Pilgrim hat," the tall, steeple-crowned beaver hats for which they are known (but without the anachronistic buckle), that belonged to Constance Hopkins. The 1904 library addition houses over 250 rare volumes, some dating back to the sixteenth century and earlier! The stately bronze bookcases and stained-glass windows today look down on schoolchildren engaged in special projects as well as researchers from around the world. The research library resources are open only to scholars by special appointment.

Pilgrim Hall is undergoing its first renovation since 1904, adding a new universally accessible entrance, new gallery and storage space, climate control (sorely needed in the past) and a professional redesign of the permanent exhibit. The new exhibit design is by award-winning Christopher Chadbourne & Associates of Boston, who recently completed work on the National Museum of the Marine Corps as well as work at Mount Vernon. When completed, the new exhibit will engage visitors in the upper hall with the Pilgrim story as it has evolved over the years through myths and inspirational art, while the lower

Pilgrim Hall exhibit design, 2007. New exhibits provide a clear perspective on the Pilgrim story, with the factual history about the colonists in the lower gallery and their mythical significance explained in the main hall.

hall will present the true history of the Plymouth colonists. The new gallery will house temporary exhibits on topics related to the larger context of the Pilgrims and Plymouth history. Pilgrim Hall is open seven days a week from 9:30 a.m. to 4:30 p.m., except for Christmas Day and during the month of January.

Leaving Pilgrim Hall we continue our tour north along Court Street. On the west side of the street we see the brick Standish Guards armory building (presently used as a juvenile court), built in 1906 to replace the earlier 1884 armory built behind the houses on Leyden Street and torn down during the construction of the new 1908 Main Street bridge across Town Brook. St. Peter's, Plymouth's oldest Catholic church (1873) is two doors down. Earlier, Mass was said in various public buildings, including the 1749 Court House.

20: PLYMOUTH MEMORIAL BUILDING

Across the street is the Plymouth Memorial Building, dedicated in 1926 to Plymouth's veterans of all wars. Before the Memorial Building was built, the site was occupied by the Lothrop House, built by Major William Hammatt in 1809 and sold to Thomas Hedge in 1830. The house was sold to the Plymouth Antiquarian Society for one dollar in 1919 and moved down to an adjoining lot on Water Street in 1924. We will encounter this house in its new location further along on this

Memorial Hall, circa 1930. Built in 1926 as a memorial to the veterans of all wars,
Memorial Hall has been for years the town's primary public venue for meetings and events.

tour. "Memorial Hall" (as it is popularly known and thus sometimes
confused with Pilgrim Hall, three doors to the south) is the town's civic
center. In 2004 it underwent a thorough $7 million renovation into a
modern performing arts center and concert hall with seating for 1,350.
Plans for the construction of a new parking garage on the lot behind
the hall are still under consideration.

North of Memorial Hall on the corner of South Park Avenue is
the "Brick Block," a row of six townhouses built after the Boston
model in 1871. The lot was where the Old Colony Railroad stored
firewood needed to fuel the engines before coal came into use. In
1849, for example, the railway bought 8,254 cords of wood at a cost
of $44,127.87—5,116 cords of which were bought in and around
Plymouth.

21: PARK AVENUE

The small park east of the intersection of Court and Samoset Streets
(Routes 3A and 44) was laid out in 1845 to lead to the Old Colony
Railroad station. The railway line opened in November 1845 and
gave Plymouth an important new means of access to the rest of
New England. The railroad also contributed to the obsolescence of
the waterfront and shifted the town's commercial center from Water
Street to Main and Court Streets. Once the new Route 3 bypass was

built in the early 1950s, the railroad itself became outmoded and passenger service ceased in 1959. The station at the foot of the park (where a parking lot is today) was converted into a supermarket and then replaced by the Citizens Bank building on the north side of the property. The old rail yard is now parking lots and the Village Landing shopping area.

Another part of Plymouth's vanished past haunts this neighborhood—the town's industrial heritage that flourished between 1790 and 1920 before fading away in the 1960s. During the nineteenth century, Plymouth had a substantial infrastructure of mills and factories producing cordage, tacks, nails, cotton and woolen cloth and other commodities. For example, in 1873 the Old Colony Railroad donated the land on the north side of Park Avenue so that the town could encourage the construction of a massive, four-story shoe factory. As with many incentives by communities to entice businesses to relocate today, this failed to have a lasting effect and the factory closed in 1899.

North and South Park Avenue, circa 1910. The Old Colony Railroad reached Plymouth in 1845, at which time this park was constructed in front of the new railway station.

As we continue down Park Avenue, we see the Ming Dynasty Restaurant—this was the site of the Plymouth Preserving Company, a cranberry cannery built in 1891; a rug manufacturer; and then a worsted mill before it closed during the Great Depression. Where Al's Pizza is today on the corner of Park Avenue and Water Street, the Ripley & Bartlett Tack Factory was in business from 1880 into the 1950s. West of Village Landing is the Radisson Hotel Plymouth Harbor, which is on the former site of the Plymouth Woolen Mills (later Puritan Mills) that opened in 1863 and closed in 1955. The Village Landing shopping area to the north on Water Street has an interesting assortment of stores and eating places, including a very good local ice cream store, a winery and a bakery in addition to the usual gift and clothing shops.

22: TOWN PIER

Across Water Street is the Plymouth Town Pier. Here the surviving fishing boats of what was once Plymouth's leading maritime trade are docked. There are also several boat tours available, including the Captain John Boats, which offers both deep-sea fishing and interpreted whale watches. The Town Pier and the long breakwater just to the north are a good way to see more of Plymouth's extensive

harbor, including Clark's Island (where the Pilgrims sought shelter before their famous 1620 landing), Saquish and Plymouth beaches and the Gurnet, the outermost point of land where there is an old wooden lighthouse (1842) on a forty-five-foot sandy cliff. The Gurnet was fortified during the American Revolution and again during the Civil War, when "Fort Andrew" (named for the wartime governor of Massachusetts) was built on the Gurnet and "Fort Standish" on Saquish (which is connected to the Gurnet). There are other deep-sea fishing services, including that of Captain Tim Brady aboard the *Mary Elizabeth* (April to November). Another company offers inner harbor rides particularly suited to younger visitors. "Lobster Tales" shows how lobstering is done and teaches passengers about these desirable crustaceans, while the "Plymouth Pirate Adventure" (for ages four through eleven) features music, costumes and a mock pirate vessel attack. The breakwater that extends from just beyond the Town Pier was installed about 1976 and provides a nice walkway out into the harbor and a place to fish from. There are also several good restaurants in the Town Pier area that specialize in seafood, as might be expected.

Plymouth Town Pier and boats. Plymouth's commercial fishing fleet, including both trawlers and sports fishing boats, is berthed at the Town Pier. There are also several excellent seafood restaurants nearby.

23: PLYMOUTH VISITOR INFORMATION CENTER

The segment of Water Street we are on, from Park Drive to the foot of North Street, was not laid out until 1882, before which this was the location of small ropewalks and rows of "fish flakes," wooden racks

for drying codfish. Proceeding south on Water Street we come to the Plymouth Visitor Information Center, located near the rotary across the street from Plymouth Harbor. The center contains a wealth of information and a very friendly staff to help you navigate your way around "America's Hometown." At the information center you may pick up brochures about attractions, restaurants, shopping and lodging and find out the latest schedules on special events. The "Dining and Activities Guide" will tell you about great places to shop and eat and also has centerfold maps that will make you an expert on how to get around Plymouth. You can also use the information center's free courtesy phones to make reservations for attractions and rooms, or simply to call for a taxi. For your convenience, the center sells tickets to many of the popular attractions and museums, which can be helpful in avoiding lines around town, and there are also clean restrooms. Additionally, it sells postcards, maps and the local newspaper. Just across Memorial Drive is the Hedge or Antiquarian House that, as we saw earlier, was moved here from Court Street in 1924.

There is also a large public parking lot here between the Visitor Information Center and the rear of Memorial Hall. It functions on a ticket purchase system whereby you buy time from a central machine and then display the receipt on your dashboard.

24: THE HEDGE HOUSE

The 1809 Hedge House, known locally as the Antiquarian House, is one of Plymouth's finest examples of Federal period architecture, featuring octagonal rooms in the main block and a rare intact carriage house. From its present Water Street location, the Hedge House Museum overlooks scenic Plymouth Harbor. Period rooms reveal the richness of nineteenth-century social and domestic life, with China Trade treasures, American furnishings, paintings, textiles and toys on display. The Hedge House was closed to the public from 2002 to 2007 for extensive restoration. The Plymouth Antiquarian Society undertook the restoration and refurbished the interior of the house with documented historic paint colors, wallpapers and period carpets.

Continuing south on Water Street, we cross Chilton Street and pass several restaurants and shops such as those that are in the old Mabbett factory building. George Mabbett & Sons was founded in 1900 and manufactured fine quality worsted for men's suits. Unlike the nearby Puritan Mills, Mabbett's prospered after World War I, expanding its facilities in the 1920s and installing automatic looms. In 1940 the firm employed about three hundred workers. Mabbett's continued in operation after the other Plymouth woolen mills closed, weathering the notorious Goldfine scandal of the Eisenhower years (Bernard Goldfine owned the mill in the 1950s). Mabbett's finally closed in the early 1960s, and was later converted to its present uses.

The Antiquarian or Hedge House. The Hedge House (1809) and carriage shed were originally located on Court Street where Memorial Hall is today, but they now grace an excellent waterfront setting.

Across the street on the harbor side, there is a small park (Mabbett's Park) with benches and a wonderful view of the inner harbor, as well as memorials to people lost to the sea.

25: WINSLOW AND NORTH STREETS

Crossing Howland Street we come to the Governor Bradford motel (built on the site of one of the Mabbett's mill buildings) and the foot of Brewster Street. Crossing over, we leave Water Street (where there are several more shops and eateries) and walk up Winslow Street, which curves sharply west before joining North Street. North Street, which was set out as "New Street" before 1633, is one of Plymouth's most picturesque neighborhoods. At the intersection of Winslow and North Streets, we come to the elegant Winslow House, owned by the General Society of Mayflower Descendants since 1941.

North Street. Laid out as "New Street" before 1633, this dignified old Plymouth street marked the northerly boundary of the original "downtown" section over three hundred years ago.

25A: THE WINSLOW HOUSE

Built by Edward Winslow (not the Pilgrim) in 1754 with timbers and carvings imported from England, the house was abandoned when Winslow, a Tory, fled to Canada after 1781. The property passed to the Jackson family, and Lidian Jackson married Ralph Waldo Emerson here in 1835. Following ownership by Reverend George W. Briggs, the Winslow House was bought by Charles L. Willoughby of Chicago in 1898, who engaged Joseph Everett Chandler to "restore" the house. What he actually did was thoroughly embellish a simple, spare eighteenth-century home by adding wings, porches, balustrades and a cupola, making it a handsome romantic fantasy in the Colonial Revival style. The Mayflower Society House, as it is usually called, is open to the public Friday through Sunday, June and September to October 12, and daily July through Labor Day, 10:00 a.m. to 4:00 p.m.

General Society of Mayflower Descendants House. The elegant decorations of the Winslow House (1755), such as the porches, balustrades, wings and cupola, are Colonial Revival additions from the 1890s.

Next door is the brick Jackson House (36 North Street), built by Samuel Jackson about 1775, and in the possession of the Russell family until the mid-twentieth century. Across the street is 35 North Street, built by brothers Abner and Jacob Taylor in 1829, and later opened as a museum by the late Franklin Trask, founder of the Priscilla Beach summer theater. The Taylor brothers were the masons who built Pilgrim Hall. Next is 29/31 North Street, an ancient house (now a tea and antiques shop) built before 1738 and remodeled by the Taylors, whose grandfather had bought it in 1755. We then come to the Spooner House Museum at 27 North Street, owned by the Plymouth Antiquarian Society.

25B: THE SPOONER HOUSE

Built in 1749 by Josiah Rider, the house was inherited by Deacon Ephraim Spooner's wife Elizabeth, and occupied by the Spooner family until the death of the last heir, James Spooner, in 1954. Mr. Spooner was a lifelong supporter of tradition and the arts in Plymouth and kept the old house essentially as it had been since the nineteenth century. The two-story house, complete with its original furnishings, including china, paintings and furniture, shows two hundred years of domestic life in Plymouth. The Spooner House and its enclosed garden are open seasonally for guided tours. Open from mid-June until Columbus Day weekend, Thursdays and Fridays from 2:00 p.m. to 6:00 p.m. and Saturdays from 9:00 a.m. to noon

Across Spooner's Alley is the former 1901 Russell Library building (the library moved to a much more commodious building at 132 South Street in 1991) and the attached Jackson House ("The Lindens"). Efforts are now underway to turn this into an arts center. Although there are other old and interesting buildings, including a very good antiquarian bookstore, the one with the greatest historical interest is the brown gambrel-roofed Warren House on the corner of North and Main Streets.

The Spooner House Museum. Home to the Spooner family from the mid-eighteenth century to 1954, the house retains its family furnishings—an excellent historic example of a prosperous Plymouth family's residence.

25C: The Warren House

Occupied today by shops and offices, this venerable house has undergone many changes (such as losing its central chimney) since it was built by General John Winslow (1703–1774) about 1726. Winslow is famous as the colonel who evicted the Acadians from what became Nova Scotia in 1755, as commemorated by Longfellow's "Evangeline" (1847). Winslow sold the house to General James Warren (1726–1808), who organized Plymouth's Committee of Correspondence, served as speaker of the Massachusetts House of Representatives, was president of the Provincial Congress and paymaster general in the Continental army.

James Warren's importance in Plymouth history is matched by that of his wife, Mercy Otis Warren (1728–1814). She was a perceptive and prolific author of plays, satires and a major history of the Revolutionary War, *The History of the Rise, Progress and Termination of the American Revolution* (Boston, 1805). A wonderfully intricate card tabletop embroidered by Mrs. Warren is on display at Pilgrim Hall.

26: Shirley Square and Main Street

Plymouth was one of the first towns in America to have running water supplied by an aqueduct of wooden pipes, which was constructed in 1797. In addition to supplying water to private houses, there were reservoirs installed in 1829 under Town Square and on Shirley Square at the head of North Street for fire engines. The town bought its first fire engine in 1757. Elsewhere, each householder was obliged to have a hogshead of water on his or her property. Shirley Square, named after James Shirley, the Pilgrims' London partner, is the small, bricked area with trees in front of the Warren House.

The Warren House and Shirley Square. Although much changed, the frame of this old house is essentially as it was in 1720s when General John Winslow built it, or in 1776, when James and Mercy Otis Warren lived here.

We may be in one of the older parts of the town, but once again so many changes have taken place that Main Street is in appearance a nineteenth-century thoroughfare, not unlike any number of other New England towns. Most of the older houses are gone, although some fragments remain. On the west side of the street (almost all of which was part of the Bradford lot on Town Square), there are two old clapboard structures. The house at 26 Main Street only dates to the 1830s, but 32 Main Street contains some 1750s framing within the enlarged structure. Where the "Puritan Clothing" building (now a café and an Indian restaurant) is today, there was until the 1930s a house built by Nathaniel Howland in 1697 that later became Ballard's Saloon and Rooming house. Across the street where the old 1878 fire station, now a Mexican restaurant, stands on the east side of the street, there was for many years a venerable colonial mansion, the Haywood House (1685), where the Old Colony Club once met. Both have vanished without trace.

The building on the north corner of Middle Street (Union Hall) was built about 1856 and bought by the Plymouth Freemasons in 1869, who met on the second floor. In the basement there was an oyster house (one of several in Plymouth). Oysters were a popular form of fast food in the nineteenth century, and they usually shared a menu with ice cream, as both required refrigeration. Before it burned in 1846, Union Hall's predecessor, the Pilgrim House Hotel, was one of Plymouth's liveliest spots each morning as the Boston and Cape Cod mail stages arrived simultaneously to exchange postal bags and passengers. The stage service had been instituted in 1796 and there were two stages

Main Street, circa 1895. Main Street became Plymouth's center of commerce after maritime trade on Water Street declined following the Civil War.

each day. The Boston mail stage left from the City Tavern on Brattle Street at 5:00 a.m. and reached Plymouth at 10:30 a.m., with three changes of horses, and the "accommodation" or passenger coach left Plymouth at six or seven o'clock in the morning, leaving Boston again at 2:00 p.m. and made stops in Dorchester, Quincy, Weymouth Landing, West Scituate, Hanover, Pembroke, West Duxbury and Plymouth. The Cape Cod stage from Falmouth and Sandwich that arrived in Plymouth at 10:30 a.m. brought mail and passengers to change for the Boston route before returning with southbound mail and passengers. The stage fare from Boston to Sandwich in 1810 was three dollars and sixty-three cents.

27: MIDDLE STREET

The stores on the south side of Middle Street are on the 1620 Hopkins lot, so the 1622 palisade gate presumably blocked Main Street at approximately this point. Turning down Middle Street (laid out in 1725 as King Street, a name it lost at the time of the Revolution), we find few historical structures. The south side is today one long parking lot, where years ago Plymouth's main livery stable (later a garage), the printing plant of the local newspaper, the Old Colony Memorial (founded in 1822) and a number of residences once stood. On the north side, about where the brick G.A.R. hall and former Boys' Club is, a church was built in 1744. The division of the Unitarian and Congregational churches mentioned while we were in Town Square

The Thompson Phillips House. Located on Middle Street, this is Plymouth's best-documented haunted house, which was once owned by John Hancock of Boston.

was the second time conservative and progressive elements split the Plymouth congregation. The first break occurred during the Great Awakening in the 1740s when itinerant evangelical preachers such as Andrew Croswell and George Whitefield stirred Plymouth audiences to adopt new forms of worship. This appalled the "old lights" or conservative members of the church, and consequently eighty members, including Josiah Cotton and Elder Faunce, broke away and formed Plymouth's third church (the second being the Manomet congregation). They built their new meetinghouse here on Middle Street and maintained their independence until 1783, by which time the emotions of the revival had cooled. The two factions reunited in Town Square, only to split again permanently in 1801.

28: THOMPSON PHILLIPS HOUSE

We have nearly returned to our starting place at Cole's Hill and Plymouth Rock. There is perhaps one last building of note. The Thompson Phillips House (1726) at 32 Middle Street was built by a Captain Phillips, who was lost at sea in 1729. Besides its antiquity, this old dwelling has the distinction of being Plymouth's best-documented haunted house. Like the Winslow House on Winslow Street, it was built with timbers imported from England. After Phillips's death, his father-in-law Josiah Cotton rented out rooms in the house. The supernatural trouble occurred in 1733 when strange blue lights were

seen in uninhabited rooms and sounds of groaning and slamming doors heard, whereupon the tenants fled the place. The reason we know about this is because a suit was brought by Cotton against his tenants claiming that the supposed haunting was just a ploy to avoid paying rent and that the stories effectively destroyed the value of the property. Cotton lost in court, however, and eventually moved his own family into the house (with no further problems). After it was sold, none other than John Hancock of Boston seized the unlucky property for debt. With this curious story we arrive back on Cole's Hill, and making our way down the granite steps to Plymouth Rock, we come to the end of the downtown tour.

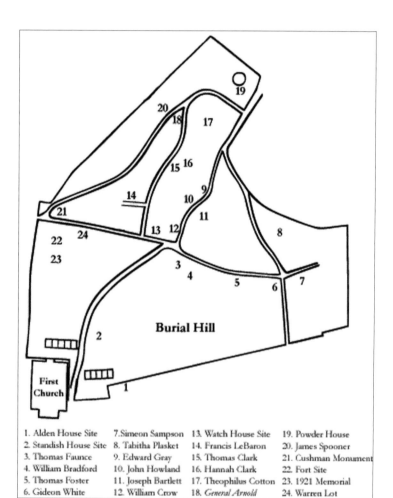

1. Alden House Site	7. Simeon Sampson	13. Watch House Site	19. Powder House
2. Standish House Site	8. Tabitha Plasket	14. Francis LeBaron	20. James Spooner
3. Thomas Faunce	9. Edward Gray	15. Thomas Clark	21. Cushman Monument
4. William Bradford	10. John Howland	16. Hannah Clark	22. Fort Site
5. Thomas Foster	11. Joseph Bartlett	17. Theophilus Cotton	23. 1921 Memorial
6. Gideon White	12. William Crow	18. *General Arnold*	24. Warren Lot

Burial Hill. Plymouth's ancient graveyard after 1637 until the Vine Hill and Oak Grove Cemeteries were opened in the mid-nineteenth century.

Plymouth Walking Tour 2
Burial Hill

Burial Hill rises above downtown Plymouth at the upper end of the Town Square. The hill's commanding height (about 165 feet), which drops away steeply on three sides, recommended it to the Pilgrims as an ideal place to erect fortifications for the defense of the settlement. They described it as "a great hill, on which we point to make a platform and plant our ordnance, which will command all round about; from hence we may see into the bay and far into the sea." In February 1621, they dragged several cannon up the slope and mounted them on a gun platform on the southwestern spur of the hill. The platform was replaced with a wooden blockhouse or fort in the spring of 1622, the lower part of which served as the colony's meetinghouse until 1648. Known during the seventeenth century as Fort Hill, it is not certain when it was first used as a burial place. As we noted on the first tour, Plymouth historian William T. Davis (1822–1907) thought that it became the town churchyard in 1637. The earliest stone marker on the hill, however, is that of Edward Gray, dating to 1681. The use of slate headstones did not come into fashion here until then, as the stone had to be imported from England. Presumably, wooden markers were used earlier, as they were in England as well.

We begin our tour at the junction of Town Square and School Street, which runs along the eastern slope of the hill. There are several modern monuments here, including one to John and Priscilla Alden, whose first home (circa 1622) stood where the street is today. Another plaque honors

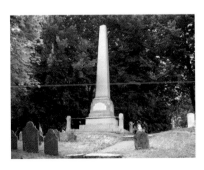

Cushman Monument. The 1858 memorial obelisk to Robert Cushman. He missed the *Mayflower* voyage, but visited in 1621 with his son Thomas, who stayed and became Plymouth's second church elder.

General Alexander Scammell, who taught school here before the Revolution. Scammell, a member of Plymouth's Old Colony Club from 1771, became a general in the Continental army and died at Yorktown. Other memorials commemorate Edward Doty and William Brewster.

Next to the granite First Parish Church is a handsome flight of brick and stone stairs built over the earlier steep path up to the crest of the hill. Above a line of tombs to our right is a small depression with a beech tree at its center. It is approximately here that Myles Standish's house is thought to have stood. In the 1630s, this location was occupied by Lieutenant William Holmes, who had charge of the fort after Standish moved to Duxbury. It is thought that Holmes took over Standish's earlier residence as well as his responsibility for the town's defense. To our left is the old hearse house, where the horse-drawn town hearse was (and is still) kept.

At the top of the stairs we turn right to begin our circuit of the ancient burying ground. Here we see several good-sized slate headstones facing north beneath a small tree, the easterly one of which has a handsome scallop shell—the classic symbol of a pilgrim—and a skeleton on it. This is the resting place of Thomas Faunce (1647–1746), last elder of the Plymouth church and the source for the traditions about Plymouth Rock. If we turn and look north from the elder's stone, we spy a small obelisk. This monument was erected in 1825 and is dedicated to Governor William Bradford (1590–1657). Like Standish's house, the location of Bradford's grave depends on tradition rather than records, as no stone marked the governor's grave when he died in 1657. However, his son Major William Bradford requested that he be interred next to his father when he died, and this is where he was buried in 1704 (look for his reddish slate marker set into a granite frame), so it is reasonable to assume the governor lies here as well. The Hebrew inscription ("Jehovah is the help of my life") was added perhaps in recognition of Bradford's efforts to teach himself to read that language.

Returning to the path running north along the crest of the hill, we come to a handsome stone with a large skull and crossbones inscribed to Thomas Foster (1703–1777). Foster was a deacon of the church and a conservative Loyalist who was chased into the woods by a mob before he "recanted" and gave reluctant allegiance to the Patriot cause. He died during the wartime smallpox epidemic. Nearby, approaching the northerly steps from School Street, is the crumbling slate stone set in granite of another Loyalist, Gideon White (1717–1779). His son Cornelius, who is also remembered here, joined the British forces and was lost at sea a few months after his father died.

We can also look out over the town and the harbor here to the long sand spit of Plymouth Beach and beyond. There are three low hills in view outside of the beach: the one at the left is Clark's Island, where the Pilgrims found shelter on December 8, 1620; the middle

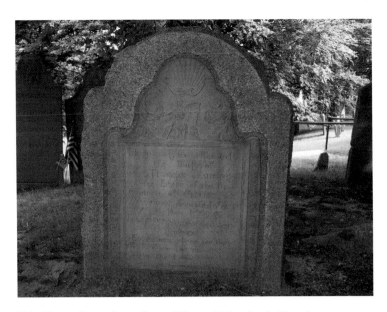

Elder Thomas Faunce Stone. Grave of Plymouth's last church elder, who was responsible for the identification of Plymouth Rock in 1741.

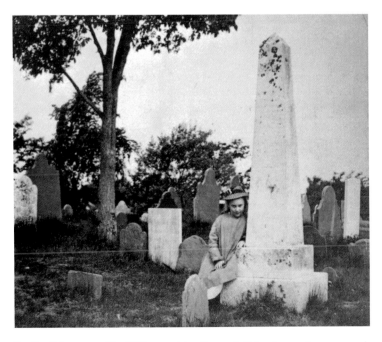

Bradford Monument. The 1825 memorial to Plymouth Colony's second governor and historian, William Bradford.

one is Saquish, an eminence on the beach that extends from Duxbury; and the one on the right is Gurnet Head (with its ancient wooden lighthouse) that marks the entrance to the harbor.

On the other side of the steps is a large slate stone with the image of a thin willow and large urn dedicated to one of Plymouth's leading patriots—Captain Simeon Sampson (1736–1789). Sampson was the first naval officer commissioned by the Massachusetts Provincial Congress and was captain of the *Independence* (built in neighboring Kingston—where Sampson himself was born) and several other American naval vessels. He had an outstanding war record and retired to a farm in Plympton after his patriotic services were no longer needed. First buried on his farm, Sampson's body was later reinterred here in honor of his service.

Turning west and taking the lower path above the parking lot, we see to our right the stones for Joseph (died 1794) and Tabitha (died 1807) Plasket. Joseph's slate stone has a large cherub, while Tabitha's has the subsequently fashionable weeping willow and urn. Mrs. Plasket became famous as the proprietress of one of Plymouth's early "dame schools" and her home on Court Street has an identifying marker. Her fame seems to derive chiefly from the popular fascination with public education that arose in the late nineteenth century—and the fact that her house became a public tearoom.

We continue along the path until we come to a junction with another path at the left and turn back toward the crest of the hill. There are several lesser paths in this area, which is the oldest section of the graveyard. Our directions only concern the wider primary paths. We next come to one the earliest dated—and probably the oldest—stone on the hill, that of Edward Gray (1629–1681), a wealthy merchant and leading Plymouth businessman. East of the Edward Gray stone is a nineteenth-century slate marker with a sailing ship on it that asserts that John Howland (circa 1599–1672/3) was buried here. However, there is no real evidence that he was actually buried on Burial Hill rather than on his own farm in Rocky Nook, and although later members of the Howland family do lie here, the presence of John's ashes may be debated. Joseph Bartlett's stone is just beyond the Howland marker, on the left side of the path. It is a fancy stone with flower-like rondels on the sides and a winged skull between an hourglass and crossbones at the top.

Edward Gray's date is the earliest, but there is a dubious tradition that the actual first stone on the hill was that of Joseph Bartlett (died 1703), and when the Gray family saw the impressive stone marker, they had a stone installed for Edward Gray after the fact. Whatever the truth of the matter, there are six original stones with seventeenth-century dates (which casts some doubt on the Bartlett tale): Edward Gray (1681), William Crow (1684), Hannah Clark (1687), Thomas Cushman (1691), Thomas Clark (1697) and—although the inscription has scaled off—a tall slate stone for the sons of John Cotton, once

Site of the watch house. A brick watch house was built here to defend the north approach to the fort in 1643.

dated 1699. The William Crow stone (in a tan granite frame) is next to the path on the right just before we return to the main path along the crest of the hill, while the Hannah Clark stone (with a winged skull, also in granite) is west of the Thomas Clark marker, which we will come to later.

Returning to the main path, we turn right and head south until we reach a junction with another path heading northwest, parallel to the path with the oldest stones. On the southerly corner is a small marble "stool" marking the site of the Pilgrim watch house built in 1643 to defend the fort from surprise attacks from the north or northwest. Four low granite posts show its original dimensions. The structure was given to Samuel Jenney after King Philip's War, just as the timbers of the main fort were given to Sergeant William Harlow (see Tour 4). Making our way west along this middle path, we come to the old stone (of slate, with a cherub and an hourglass, within a granite frame) of Dr. Francis LeBaron (1668–1704), immortalized in Jane G. Austin's *A Nameless Nobleman* (1888). LeBaron was a French physician who came to live in Plymouth after being shipwrecked off Cape Cod in 1696. Austin's imaginative fictional account was very popular for generations, and visitors still come to see the grave of the famous Dr. LeBaron.

Backtracking onto the path we just left, we continue west. On our right is a large, rough boulder with a bronze plaque to the memory of Thomas Clark (died 1697), who came to Plymouth aboard the *Anne* in 1623. For many years, this grave was misidentified as the grave of the Clark who was mate of the *Mayflower*—despite the fact his name

Francis LeBaron Stone. The grave of the French physician who was immortalized by Jane G. Austin as the "Nameless Nobleman" in her best-selling novel of the same name in 1888.

was John and he returned to England. The present memorial (erected by Thomas Clark's descendants in 1891) corrects the earlier error. Nearby is a smaller and older stone to the memory of Thomas Clark's son Nathaniel (1644–1717), Plymouth's first lawyer and notorious as the "creature" or agent for the hated Royal Governor Sir Edmund Andros. Nathaniel Clark used his political influence to have "Clark's Island" in Plymouth Harbor, which was town property, deeded over to him. Clark's Island was named for the mate of the *Mayflower*, but to Nathaniel the name may have suggested the appropriateness of his private ownership. Clark was expelled from the Plymouth Church after shouting back against criticism from the pulpit, and he had a committee of local men who protested his seizure of the island arrested for "illegal taxation" (what we would now call fundraising) and sent to trial in Boston. When Andros lost his position and was arrested by the Bostonians in 1689 during the Glorious Revolution, Clark was seized in Plymouth and shipped off with his master to England. He later returned to his native town and took up the practice of law, to which his argumentative nature was well suited. Across one of the lesser paths behind the Clark marker is the 1687 stone for Hannah Clark (look for a winged skull).

Further along the path is a stone facing the Powder House with an elaborate cherub in a protective copper hood for Colonel Theophilus Cotton (1716–1782), the Plymouth military commander who extracted Plymouth Rock from its bed and transported it to Town Square in 1774. Cotton also led a thousand local militiamen to confront the Queen's Guard in neighboring Marshfield in April 1775. The British troops had been sent to protect local Loyalists and possibly seize Plymouth's gunpowder supply. Cotton, having no orders to attack, simply watched the British flee back to Boston. If there had been hostilities, we would now be remembering Marshfield as where the American Revolution began on April 8, rather than at Lexington and Concord on April 19, 1775.

Turning left at the end of the path, we come to a small obelisk on the west or left side of the path, which is the memorial to the wreck of the *General Arnold* (1778), Plymouth's most tragic shipping disaster. The *General Arnold*, an American brig of twenty guns with a crew of 105 under Captain James Magee arrived in Plymouth Harbor on Friday, Christmas Day, 1778. There was no available pilot to guide the ship through the torturous channel, so it anchored in the "Cowyard,"

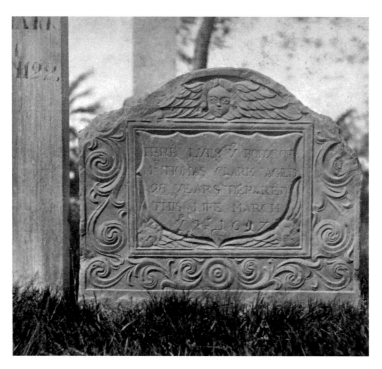

Thomas Clark Stone. For many years misidentified as the grave of the mate of the *Mayflower*, there is now a modern stone given by the descendants of Thomas Clark correcting the error.

General Arnold Monument. The memorial to the victims of the 1778 *General Arnold* marine disaster. Captain Magee was later buried here along with his crewmen at his request in 1801.

just inside the harbor. A stiff wind drove the vessel onto a mudflat where it began to take on water and sank ten feet into the mud just as a tremendous blizzard developed. Unfortunately, the drunkenness of the crew (who were presumably celebrating the holiday) and the weather prevented many men from escaping the foundered vessel. Rescue parties from Plymouth (who could see the *General Arnold* three miles or so out in the harbor) were unable to reach the ship during the two days of the storm. On Monday, December 28, they were finally able to reach the ship and found 70 frozen bodies and scarcely more survivors. The corpses were taken ashore for burial and stacked in the courthouse in Town Square, and 10 men who were to be placed in coffins were put in Town Brook to thaw. The memorial marks the spot where 60 common seamen were buried in a mass grave. Captain Magee survived, but asked to be buried along with his mates in Plymouth when he died in 1801. A book has been written about the "discovery" of the timbers of the *General Arnold* in Plymouth Harbor, but as the U.S. government later floated and reclaimed the hull (the paperwork survives), such claims can be dismissed. More than a few vessels have come to their end in these waters. We now turn and approach the small round brick structure at the very end of the hill area. This is a re-creation of the original powder storage building that stood here from 1770 to 1880 on the site of a small fortification built by Plymouth students during Queen Anne's War (1702–13). The present structure was built for the Plymouth tercentenary in 1921.

Taking the path below the *General Arnold* memorial, we find the last stone to be erected on Burial Hill, that of James Spooner (who owned the Spooner House on North Street), who somehow convinced authorities to bury him in his family's plot in 1954. Skirting the southwestern side of the hill, we come to the most impressive memorial on Burial Hill, the Cushman Monument. This obelisk was erected in 1858 in the memory of Robert Cushman (1578–1625) and his son Elder Thomas Cushman (1607-1691) on the site of the latter's grave. Robert Cushman was an original Pilgrim who chose to remain behind when the *Speedwell* was found to be unseaworthy at Plymouth in England. He had been one of the agents who had hired and provisioned the *Mayflower*, and he made the crossing aboard the *Fortune* in 1621, but returned to England where he died in 1625. His son Thomas accompanied him in 1621 and stayed in Plymouth Colony, becoming elder of the church after William Brewster died in 1644. Thomas's nearby original slate stone has a winged skull on it.

East of the Cushman Monument a narrow path leads to another marble "stool" marker, indicating where the center of the Pilgrim fort was. The last blockhouse erected here during King Philip's War (1675–76) was about twenty square feet (the outlines of its foundation are still faintly visible to the south and east as a low ridge among the graves). Just east of the fort site is a cement platform with an iron fence and a memorial that commemorates the fort meetinghouse. In

Site of old fort. Dr. James Thacher planted an elm tree at the center of the old fort's foundation, which was later replaced with the marble "stool."

1921, two period bronze cannon with modern iron carriages given by the British government were installed here as part of the Plymouth tercentenary observation, but they were removed in the 1970s for fear of vandalism. One was returned to the Isle of Guernsey (where it had originated) and the other can be seen today in Pilgrim Hall (see Tour 1).

Returning back to the main path, we find an iron-fenced "yard" in which the stones of the Warren family are located. The most memorable individuals buried here are General James Warren (1726–1808) and his wife Mercy Otis Warren (1728–1814), the well-known Patriot and his wife—author and chronicler of the American Revolution. In addition to their original marble stone, General Warren has a bronze memorial erected in 1923 by the Sons of the American Revolution. Their home, on the corner of North and Main Streets, is mentioned on Tour 1. We now return to the brick stairs leading back down to Town Square and so complete our tour of old Burial Hill.

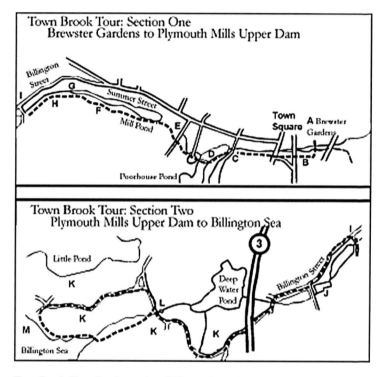

Town Brook. Town Brook runs from Billington Sea to Plymouth Harbor, about a mile and a half in length.

Plymouth Walking Tour 3
Town Brook

A lthough Town Brook from Plymouth Harbor to Billington Sea is only about a mile long, its course is rich in both history and natural beauty. It is possible to walk the entire length of Town Brook and, except for one stretch on Billington Street, remain in parks and woodlands, including a section of the old Nemasket Path that has changed little since it was a Native American trail before the arrival of the Pilgrims. The Wampanoag Indian name for the area was Patuxet (or alternately, Accomack—"on the other side" of the harbor—from the perspective of those Native families who lived north of Duxbury Bay). Patuxet means "at the little falls," and it was here on the harbor side and along Town Brook that the Patuxet people had their summer planting fields, which were abandoned after the terrible epidemic of 1615–1618. The main village site was by report at the other end of the brook near the large pond or lake called Billington Sea, where the brook rises.

As the Patuxet before them did, the Pilgrims found Town Brook a bountiful resource for the schools of herring (alewives, *Alosa pseudoharengus*) that streamed up the brook each spring, and as power for their first corn mills—a pounding mill near Billington Sea built by Stephen Deane in 1632 that was superseded by Samuel Jenney's gristmill in 1636. After the American Revolution, Plymouth grew from an agricultural and fishing community to become an industrial center. Mills and factories were built along Town Brook, which was divided into "water powers," where industries were given rights by the town to use the brook to power mills for manufacturing iron goods, woolen and cotton cloth and other commodities. Although the original mills no longer exist, the mark they made on the landscape is still evident today and constitutes an important part of Plymouth's history.

A: BREWSTER GARDENS

We begin our tour at the entrance of the Brewster Gardens Park, which was created in 1924 on filled land over the old "Town Pond" at the mouth of the brook. Originally this area was a tidal estuary and the brook flowed freely through salt marsh and sedge flats up to the first falls just beyond Market Street Bridge. At high tide it was possible for small coastal vessels (similar to *Mayflower II*'s shallop) to enter the mouth of the brook and tie up at one of four small wharves or quays built to receive marine traffic. Two of these wharves on each bank were connected with a "swinging bridge" (about where the small wooden footbridge is today) that could be shifted to allow boats to go farther up the brook. In 1759, however, a bridge was constructed across the mouth of the brook where Water Street crosses today, and in 1821 a dam closed the tidal access and raised the height of the brook about ten feet. The resulting stagnant pond became polluted and noisome until it was filled in to become Brewster Gardens.

The land around the wooden pergola was once a shipyard where vessels were built and where goods were unloaded from larger ships out in the harbor. After the Revolution, the town was forced for financial reasons to sell the shipyard property. The Robbins Cordage Company then built a rope factory here. The ropewalk extended from about where the pergola is all the way up and over the brook to the dam and original 1636 Jenney gristmill on Spring Lane. A ropewalk needs to be equal to the length of the longest rope being made. The ropewalk and the ancient mill both burned down in 1847. The last of the brook side buildings were removed in the 1920s, although until the 1960s a large brick electrical plant occupied the area where we now enter the park. William Brewster owned land on both sides of the brook—his house lot on Leyden Street and his planting fields that covered the land south of the brook between Water Street and the brook itself.

Brewster Gardens was created following the 1920 tercentenary by Mrs. Richard Greene, Mrs. Benjamin Jackson and Mrs. William Forbes, daughter of Ralph Waldo Emerson and Lidian Jackson Emerson. There are several memorials in the park, including the stone dedicated to Mrs. Emerson and her brother Charles Jackson above the now sadly polluted spring, and most strikingly, the impressive bronze statue of the Pilgrim Maiden on a twelve-ton boulder. Sculpted by Henry H. Kitson, this memorial was the gift of the National Society of New England Women, and dedicated in 1924. The recent refurbishment of the park by the Town of Plymouth in 2005 under the direction of George Crombie has restored much of the original beauty to the gardens. A stainless steel sculpture by Barney Zeitz honoring Plymouth's *other* immigrant settlers from 1700 to 2000 can also be seen in the park. The small fieldstone building near the Main Street Extension bridge was installed in the nineteenth century to pump water up to the Brewster Drinking Fountain near the old post

Immigrants' Memorial. A stainless steel sculpture by Barney Zeitz (1951–) honoring Plymouth's immigrant settlers from 1700 to 2000—too often overlooked amid the adulation of the *Mayflower* Pilgrims.

The Pilgrim Maiden. The 1924 bronze memorial sculpted by Henry H. Kitson (1863–1947) honoring young *Mayflower* women. It reflects the assertive "New Woman" of the 1920s, who had just gotten the vote in 1920.

office. A new fountain was installed after Main Street Extension was built, but it no longer functions.

B: TOWN BROOK PATH

Crossing the wooden footbridge, we step on to the south bank of Town Brook, once disparagingly known as "T'other Side." There is a small stream running through a culvert into Town Brook that is all that is left of Barnes' Creek, which once drained the marshes at the lower end of Bradford Street. As we walk along, you may notice the rusty-colored water that is seeping out of the hillside springs. The coloration isn't pollution but ferric hydroxide, the source of the "bog iron" that collects as sediment in ponds and swamps locally. The deposits were the source of the iron ore that the local smelting works in Carver and elsewhere turned into the iron used in Plymouth mills to make anchors, sheet iron and nails. During the summer season the brook here is lined with wild flowers including buttercups or "crowfoot," watercress (which the Pilgrims were pleased to find as a winter source of nutrition) and forget-me-nots.

Market Street Bridge rapids. The small run of rapids here on Town Brook (looking east) may have provided the Wampanoag name of "Patuxet" for Plymouth, meaning "at the little falls."

Passing under the 1908 Main Street Extension Bridge, we come to a grassy bank with several springs flowing from it. There was a rum distillery here in the eighteenth century that made good use of the fresh water, and later there were houses on Sandwich Street above

us that were removed during the urban renewal of the 1960s. The next bridge over which Market Street passes was constructed in 1966, replacing the old 1812 bridge, which was much lower and impossble to walk beneath. The clearance of the buildings on Sandwich Street and Bass Place (west of Market Street) and the installation of the new bridge connected Brewster Gardens with the new Jenney Pond Park constructed on the site of Plymouth's poorhouse, where the parking lot is now. Continuing along the path we see a small wooden bridge crossing the brook. On the north bank there is an old granite horse trough with a memorial marker. We continue along the south bank path until we come to a restaurant and the reconstructed Jenney Grist Mill (1970).

C: JENNEY GRIST MILL

This re-creation of Plymouth's first gristmill on Spring Lane is on the site of the original 1636 mill built by John Jenney that burned down in 1847. It is a functioning mill and visitors can see it grind corn from time to time. They sell stone-ground meal, and there is an ice cream shop with a deck over the brook where the millrace and mill wheel can be observed. The proprietors also offer a sixty-minute walking tour of old Plymouth. Open daily from 9:30 a.m. to 5:00 p.m., April 1 through December 24 (except Tuesdays).

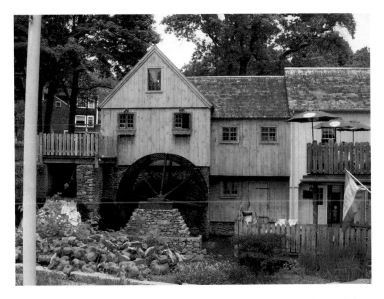

Jenney Grist Mill. Built on the site of the original 1636 mill in 1970, the Jenney Grist Mill operates as a functioning museum today.

A herring ladder. Dams built on Town Brook hindered the alewives in their annual passage to Billington Sea to spawn, so "ladders" such as this were installed to allow them passage.

Next to the mill on the north side is a "herring ladder," a series of stepped pools by which fish may migrate upstream to spawn each April. The alewives fill the brook as they progress slowly upstream.

D: POORHOUSE POND

Although the millpond is now called in its entirety Jenney Pond, the older usage was to denote the pool by the dam at Spring Lane as the millpond and the larger pond to the south as Poorhouse, or Alms House, Pond. The 1826 brick almshouse and outbuildings built for Plymouth's poor relief were removed in 1970. Amusingly, the pond is labeled "Arms House Pond" on some older maps. Apparently that was what out-of-towners assumed the name was when they were told it was Alms House Pond in a Plymouth accent. As in Maine, there is no "r" in the middle of words in old Plymouth speech, only "ah-s."

The ponds and adjacent park form a pleasant scenic vista in the midst of downtown Plymouth. To the east is Watson's Hill, where the Pilgrims first met with the Wampanoag sachem Massasoit in 1621, and where his representative Hobbamock lived with his family on a four-acre farm in the 1620s. Frawley's Mountain, a wooded hillside, frames the south end of the pond. Many Plymoutheans come here to picnic and watch the swans, ducks, turtles and other wildlife. Town Brook enters from the west over a silted delta where the rapid flow of the little brook meets the pond.

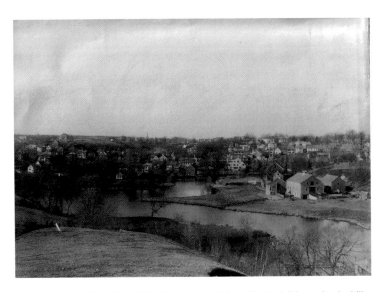

Poorhouse Pond, circa 1900. This view looks north from Frawley's Mountain, the hill above the southern end of the pond.

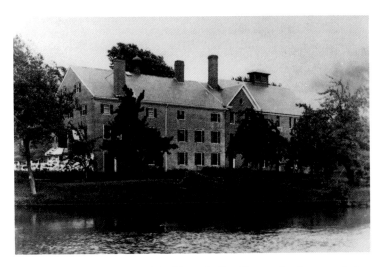

Plymouth Poorhouse, circa 1900. The Plymouth Alms House or Poorhouse was built in 1826 to provide shelter and care for the town's indigent citizens. The building was demolished in 1968 for the Jenney Pond parking lot.

Crossing Poorhouse Pond over the wooden footbridge, we pass through a traffic circle at the foot of Willard Place, which runs through the site of an eighteenth-century tannery. We continue our journey on the west side of the circle, passing between thickets of pernicious Japanese knotweed. There are also rows of jewelweed and, near the trees on the bank of the stream, now uncommon bog bean or

groundnut vines appear in season. Groundnuts are a native foodstuff that is celebrated in early records as helping hungry colonists survive through winter and early spring. The vine has reddish-brown flowers and bean-like pods, but the edible parts are tubers growing beneath the ground.

Further on, the brook divides into two channels around a man-made island that was once the site of an oil or gristmill. The brook then goes underground through a tunnel beneath Newfield Street and the former Robinson Iron Works property (now the Samuel Holmes playground, which includes a basketball court and skateboard park) on the other side.

E: NEWFIELD STREET AND HOLMES PLAYGROUND

Ascending the steps to the street, we pass children's swings and slides as we follow the gravel road by the electrical substation to the top of the old milldam. To our right is another herring ladder. When this ladder was installed to replace an earlier one to the north, much of the property that was once drained by the old fish channel became swampy and overgrown with rank weeds. Walking above the dam that replaced the 1790s one that gave way in 1906, we notice the entrance to the herring ladder and also the spillway that directs the brook into the tunnel. The old millpond up the brook to the west presents a very picturesque view. Old houses on the hillside to the north are partially hidden by tall trees while the rows of alders, maples and beech trees on the south bank make the scene look just as it has for hundreds of years.

F: MILL POND PATH

We return to the brook side path and follow the narrow sandy trail along the millpond. The first hill to our left, where there is a large nursing home today, is called Cannon Hill. Years ago, it was the custom for some men in the town to fire a cannon located in the pasture above to celebrate holidays and other events. We can look across through the trees lining the brook to see the terraces that descend to the brook behind the houses on Summer Street. The oldest is the first one heading west—the Long House. The other houses were built in the early nineteenth century for people employed in the ironworks. The path follows the brook past some ancient beech trees, and on the hillside to the left are a few patches of leathery-leaved "mayflowers," as the trailing arbutus is known here. A century and a half ago, Plymouth children earned small sums by picking these fragile, fragrant spring flowers and selling bunches of them to tourists as they arrived by steamship or railroad.

Robinson Iron Works millpond, Town Brook. The 1792 Summer Street dam (that broke in 1906 and was later repaired) sustains this placid pond that no longer powers a mill but does present a beautiful vista along upper Town Brook.

G: Boy Scout Footbridge

One incongruous note along this path is the cement-ringed manholes amid the sweet pepper and bayberry bushes. Beneath the ground is the pipe through which the Plymouth water supply is fed from Little South Pond. Ten-inch, cement-lined iron piping was installed in 1855 to replace earlier wooden pipes laid in 1797. Crossing the brook is a small, covered footbridge. The bridge was originally erected to support the pipe, which crosses from the north to the south bank here. Just as the Indian trail followed the south bank because of the steep rise of the hill on the other side, so the town utilized the relatively level south bank to lay their water system. The present footbridge was built by the Plymouth Boy Scouts, who still maintain the bridge. The earlier bridge was simply thick boards laid next to the pipe, and as these dropped away over time, it became the challenge for the boys of the neighborhood to dare one another to run and leap across the gaps without falling into the brook below.

H: Plymouth Mills Lower Dam Site

Beyond the bridge the path reverts to its original state, winding over tree roots beneath a mossy bank covered with beech trees (and in late summer, "beech drops," an interesting parasitic species found only

Covered footbridge. Built on the site of the former Plymouth Mills Lower Works, the bridge supports the primary town water main from South Pond. The covered upper portion was built and is maintained by local Boy Scouts.

on the roots of beech trees). The brook side is covered with skunk cabbage, sweet pepper bushes and other water-loving species. The carnation-like fragrance of the sweet pepper gives the walk an extra dimension for visitors on hot August days.

We now arrive in a cleared grassy area at a low stone wall. Until 2002, there was an old earthen dam and iron culvert here. The iron factory began manufacturing anchors (and later shovels, tacks and rivets) in 1800 and went out of business in 1926. The factory buildings were sold to the town, and except for a brief partial employment as a curtain factory, the buildings were used by the public works department until a fire in 1966 destroyed them. The site remained vacant until the town decided to restore the brook to its original condition by removing the dam—the first such waterway restoration in Massachusetts.

I: PLYMOUTH MILLS UPPER DAM AND BRIDGE

Continuing west, we come to a tall stone dam (and herring ladder) with a roadway running over it. This was the other section of the Plymouth Mills iron works. The factory that once straddled the brook at this point also closed in 1926 and was cleared away in the early 1930s. At this point, the walk becomes slightly more strenuous, and we suggest that the less adventurous turn back here and retrace their steps back down the brook. For those who want to continue until they come

Plymouth Mills, Upper Works Dam. The mill complex was removed in the 1930s, but the picturesque dam still sustains the quiet millpond. This is where the Town Brook Trail temporarily joins Billington Street.

to the source of Town Brook, we will go on. The accompanying map divides here into the two tour segments.

J: Standish Mills

We must now cross to the north bank of the brook and follow Billington Street, as the "Off Billington" road is a dead end and only leads to private homes. The houses on Billington Street were built for the use of the Standish Mills at the next water power and dam. In 1771, a leather factory was built here. It was succeeded by a snuff mill built in 1788 by Solomon Inglee, who also built the fine Federalist house on the south bank of the millpond. In 1821 the mill was converted to a manufactory of cotton cloth, and then a new mill was built to make cotton thread in 1855. It was refitted again in 1872 to weave cloth, and was finally converted to Standish Mills for the production of woolen worsted in 1893. The mill was closed down by 1930. There is actually a fragment of the old mill here as well as some of the old company houses. Plymco, a millwork plant making windows, operated here from the 1960s to the 1990s.

The walk from the Standish Mills dam to the entrance of Morton Park is the least inviting part of our tour, as the sidewalks cease at this point and all we can see ahead is the cavernous arch by which Billington Street passes under Route 3. The brook has its own channel under the highway, and under the old Deep Water Bridge, where the

road crosses to the south side of the brook. This was a popular scenic spot before the highway intruded, and there are postcards of Deep Water Bridge from the early years of the last century. Persevering, we go under the highway and proceed straight ahead toward the two stone pillars that mark the park entrance. The dirt road has homes and cranberry bogs to the left while swampy ground along Deep Water Pond is on our right.

K: MORTON PARK

Morton Park is Plymouth's oldest park. The park was named for Nathaniel Morton, who donated much of the land that makes up the two-hundred-acre park today. He had been struck by the comparative decrease in natural scenery in central Plymouth as he walked by the shore of Billington Sea in the early 1880s, and he conceived of having this unspoiled area set aside by the town as a public park. However, public parks outside of larger cities were still a novel idea, and Plymouth, which had a large amount of untapped woodlands, didn't see the point. It was argued that the town was mostly woods already and a park was both a waste of money and would destroy the natural beauty of the area. It appears that most citizens believed a park had to be level and orderly, rather than the natural setting Morton envisioned. Morton, however, went ahead on his own, buying the central part of the property and repairing the roads and paths. In 1889, Nathaniel Morton, Walter Sears and George Briggs became Plymouth's first park commissioners, and the property was dubbed Forest Park (later becoming Morton Park).

L: HOLMES DAM

Over the hill we find a rough stone bridge. To the right, we can see an abandoned cement millrace ("Bill Holmes' Dam") where, according to reports, Plymouth's first mill was located, built by Stephen Deane in 1632. On the other side of the bridge, there is a rough trail (not all that obviously) heading down the slope to the south side of the brook. Descending the slope, we can follow this path through the woods along the brook until it comes out at the entrance of Town Brook from Billington Sea. The less agile can continue on the dirt road to a fork just past the bridge.

From the stone bridge, the dirt road leads to a fork in the road. The right fork goes to Little Pond and a popular public freshwater bathing beach. The left fork goes uphill through pleasant groves of white pine to a landing place on the shore of Billington Sea. To the left, there is the level path that follows the shoreline to the wooden bridge at the mouth of the brook.

Billington Sea, circa 1890. From its inception, Morton Park on Billington Sea and Little Pond was a favorite summer recreation spot for Plymouth's residents and visitors.

M: BILLINGTON SEA

We have now completed our tour of Town Brook. Before we return back downstream to Billington Street and the downtown area, we should explain how this pond—all lakes are "ponds" in Plymouth, by the way—got its odd name. "Billington Sea," one of Plymouth's largest ponds (269 acres), gained its name from a story in *Mourt's Relation* (1622) that relates how young *Mayflower* passenger Francis Billington climbed a tree on the hill just west of the village, and seeing a large body of water, he told everyone that he had seen a great sea. Apparently he had heard tales of the Pacific Ocean and the legendary Northwest Passage and imagined this was the western "sea" he had heard about. The pond was called Fresh Lake through the eighteenth century, but then Billington's name was appended to it as a local joke. This led to another joke of asking out-of-towners "which is the smallest sea in the world?" Today, much of the pond's shore has been preserved in Morton Park and is enjoyed by locals and visitors alike for fishing, picnicking and swimming.

Plymouth Walking Tour 4
"T'other Side"

S andwich Street is the old road south to the town of Sandwich (founded 1636) on Cape Cod, and some very early houses still exist along the route, as in the old neighborhood of Hobs Hole or Wellingsley (so named in the 1630s). During the 1620s, the land south of Town Brook was divided into planting fields, each of which was tied to one or another of the house lots (meersteads) on First Street. For example, Elder Brewster received six acres on the north side of Water Street; Thomas Cushman got the lot of land now bounded by Water, Sandwich, Bradford and Emerald Streets; Governor Bradford's property was where the Nathaniel Morton School is today; and so forth all the way to Jabez Corner. As time went on, these lots were sold, divided and reallotted as family farms and house lots.

29: MARKET STREET BRIDGE

We begin our walking tour south of the Market Street Bridge. Pleasant Street, which extends up the hill, was only laid out in 1820, so we turn right onto Sandwich Street, passing by the former Friendly's Restaurant on our right. This lot was once owned by Giles Rickard and inherited in 1685 by his widow, Hannah Rickard, who operated a tavern out of their house. The hill above Pleasant Street between Town Brook and Stafford Street, known to the Wampanoag Indians as *Cantaughcaniest* ("the planting fields") and later called Watson's Hill, was part of the 1623 field division. Lots totaling twenty acres went to John Howland (four acres), Hobbamock (four acres), Stephen Hopkins (six acres), Gilbert Winslow (one acre), Samuel Fuller (three acres), Edward Doty (one acre) and Edward Leister (one acre). Howland received Hobbomock's land when the latter moved to Duxbury. The boundary between the Howland and Hopkins lots was where Jefferson Street is today, so "Hobbamock's Homesite" (as depicted at Plimoth Plantation) was originally near the intersection of Massasoit and Mayflower Streets at the top of the hill.

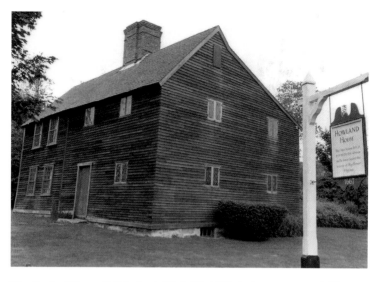

The Howland House. Built by Jacob Mitchell in 1667, the house was occupied by Jabez Howland and possibly his widowed mother Elizabeth between 1670 and 1680.

30: The Jabez Howland House (1667)

Proceeding south on Sandwich Street we come to the Howland House. The older part of this ancient dwelling was built by Jacob Mitchell in 1667 and sold to Jabez Howland a few years later. Howland occupied it until 1680, during which time it is assumed that his parents, *Mayflower* passengers John and Elizabeth Tilley Howland, often visited the house, and his mother probably lived there after John died. The Pilgrim John Howland Society bought the property in 1912 and had it restored in 1941 by Sidney and Charles Strickland. John Howland vies with John Alden for having the greatest number of descendants, which include Franklin Delano Roosevelt and Sir Winston Churchill. The house is open to the public from Memorial Day to Columbus Day. Guided tours are from at 10:00 a.m. to 4:30 p.m. Leaving the Howland House, we proceed up the hill on Sandwich Street to the Plymouth Training Green.

31: The Training Green

This land has always been owned by the Town of Plymouth, and was used as commons and for militia training starting in 1711. In the period of financial difficulty following the Revolution, the town found it advisable to sell a portion of the original green (between South Green Street and South Street), but otherwise it has remained

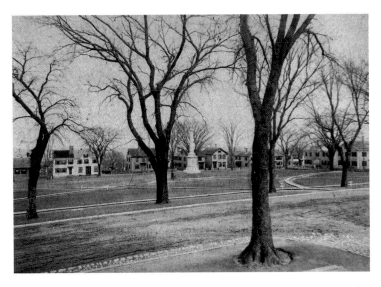

The Training Green, circa 1890. The town green was laid out south of the center of town in 1711. The Soldiers' Memorial dates to 1869, and the landscape design by Frederick Law Olmstead to 1889.

intact. A memorial dedicated to the soldiers and sailors of Plymouth who lost their lives in both the Civil War and the War of 1812 was erected in 1869. The design for the walks and perimeter curbing was done in 1889 by the well-known landscape firm of Olmstead and Sons. On the other side of Sandwich Street is Bradford Street, where there are a number of nineteenth-century houses once owned by poorer Plymoutheans, but now restored and quite fine looking. Farther along we see the Nathaniel Morton School (1913/19), named after Plymouth's Victorian benefactor, who in turn was named for his ancestor, Nathaniel Morton, Plymouth Colony's first historian (*New Englands Memoriall*, 1669) and nephew of Governor Bradford. The school is located on Bradford's former property.

32: Lincoln Street

Proceeding south we come to Lincoln Street, which was laid out in 1891 over Barnes Lane. The town's second and third high schools were built on this street in 1891 and 1930, respectively. The older building has been Plymouth's "Town House" or seat of government since 1953, when that function was moved from the 1749 Courthouse in Town Square. The school on the north side of the street, which was once the "new" high school added to the Nathaniel Morton School in 1936, is today an elementary school.

33: SOUTH STREET

On the other side of Sandwich Street, we come to South Street, an ancient thoroughfare to the fields that existed before 1700. South Street now continues past the Plymouth Library and Plymouth's police station after it passes under Route 3 and becomes Long Pond Road. The next street on the left or east side of Sandwich Street, Fremont Street, was opened in 1859 and is continued by Stephen's Lane down to the harbor. Much of the land on either side of the street from here to Winter Street (another seventeenth-century way) was acquired by Sergeant William Harlow in the 1660s. Harlow built several houses on his property, including the "Old Fort House" in 1677.

34: THE HARLOW OLD FORT HOUSE (1677)

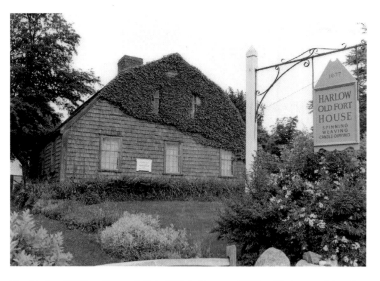

The Harlow Old Fort House. Built in 1677 by Sergeant William Harlow, traditionally with timbers given to him from the fort on Burial Hill that was dismantled following King Philip's War (1675–76).

Tradition has it that this house was built by Sergeant Harlow using the timbers from Plymouth's last fort on Burial Hill, which he was given following King Philip's War (1675–76). The Harlow House was purchased by the Plymouth Antiquarian Society in 1920 and restored by Joseph E. Chandler, a historical architect who also designed the embellishments for the Winslow House (now the Mayflower Society House) on Winslow Street. The Harlow House was opened to the public in 1923, and has for many years offered demonstrations and classes in colonial crafts. Until Plimoth Plantation opened in 1958,

the Harlow House and its costumed hostesses were the much-photographed and filmed media representation of Thanksgiving and Pilgrim life. Another tradition much enjoyed by Plymoutheans and a few summer visitors who chance to discover it is the annual Fourth of July Breakfast. This is not offered on the day of the Fourth but on the nearest Saturday morning. Tables are set up in the back garden, and traditional Yankee breakfast items such as baked beans, codfish cakes, eggs, corn muffins or "gems" and homemade relishes (as well as plenty of coffee and cranberry juice) are served by the young hostesses, while other younger girls pass among the guests peddling "tussie-mussies"—small bouquets of local flowers.

During the past several years the Harlow House has been closed to the public while undergoing an extensive preservation program. This effort is nearing completion (2007) and the old house should be available for tours and classes again in the near future.

Stephens Field. A popular Plymouth recreation area created between 1915 and 1927 over a salt marsh, with additional acreage donated by the Stephens family.

35: Stephens Field

Continuing along Sandwich Street, we come to a broad avenue on the left that leads down to the Stephens Field Park. Across Sandwich Street from the avenue is an ancient gambrel-roofed house built by Thomas Dotey before 1700. Turning down the avenue we come to Stephens Field, a seven-acre facility constructed between 1915 and 1927 on filled land over a salt marsh. The property was named for the

Plymouth Yacht Club. The Pilgrim Yacht Club moved into the old lumberyard barn in 1928, and merged with the older Plymouth Yacht Club in 1939.

Stephens family from whom some of the land was acquired. There is a softball field, four tennis courts, a basketball court, a restroom and concession building, an unpaved boat launch area and a parking lot. There is also a grassy area with a small pond, picnic tables and playground equipment for children. The lawn is sprinkled with English daisies. Following the gravel roadway we exit Stephens Field onto Union Street at the foot of Fremont Street.

36: UNION STREET

Union Street was laid out between 1841 and 1865 and follows the shore to Water Street.

37: THE PLYMOUTH YACHT CLUB

The Plymouth Yacht Club, now located in the former Atwood Lumber Company building, acquired its first clubhouse on Long Wharf in 1890, but had to move during the waterfront clearance in 1920. A second club, the Pilgrim Yacht Club, had begun in 1925 and bought the old lumberyard in 1928. The two clubs merged in 1939. Continuing along Union Street past the Plymouth Marine boatyard (in which there is a very good restaurant with a deck looking out over the harbor and the mouth of Town Brook), where the shallop for *Mayflower II* was built

in a now-vanished Quonset hut by the Jesse family, we come to a long brick building that originally was the Plymouth Iron Foundry (1866), which closed in 1935.

We next come to the corner of Water Street near the southerly entrance of Brewster Gardens. The Water Street Café on the corner, as well as the venerable Colonial Restaurant on Main Street, is one of the local residents' favorite breakfast places. Turning right we proceed up to the junction with Sandwich Street and Main Street Extension. The block formed by Water Street, Emerald Street (on our right), Sandwich Street and Bradford Street is of interest as the old single-acre field lot given to Thomas Cushman in 1623, and one of the few "first lots" that can be easily traced by the original bounds. Crossing Main Street Extension and walking along the north side of Sandwich Street above the grassy bank overlooking Town Brook, we arrive back at the junction with Market Street where we began our tour.

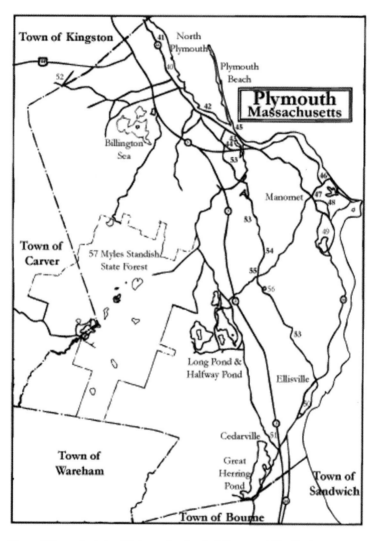

Town of Plymouth. A simplified map showing the full extent of New England's oldest English community.

Driving Tours of Plymouth's Outlying Points of Interest

W here other states have towns embedded in a larger county jurisdiction, in Massachusetts counties were an afterthought in 1685, so towns border one another and incorporate all the land available. Extensive towns such as Plymouth have several self-contained "neighborhoods" with stores, churches, schools and fire stations that might qualify as separate municipalities elsewhere. Plymouth's most important neighborhoods include North Plymouth, Chiltonville, Manomet, Ellisville and Cedarville, as well as the new Pine Hills community that will in time equal the population of the entire town in the nineteenth century. There are also amorphous areas of development such as "West Plymouth" or "South Plymouth" that contain hundreds of homes but lack the community traditions and public facilities of the older neighborhoods.

Plymouth's lengthy history and extensive area (almost one hundred square miles) makes it difficult to scope out viable tours beyond the old town center. Yet, despite previous guides' stress on the Pilgrims and downtown, there is a wealth of interesting sites and stories beyond the center of town. Likewise, a guidebook such as this cannot do full justice to the many histories that Plymouth's neighborhoods possess. We will therefore select a few highpoints on expeditions north and south along Plymouth's primary thoroughfare (Route 3A) and a few other locations among the town's widely spaced sites of interest.

Starting from Town Square, we follow Main Street north (which turns into Court Street at Shirley Square) past the 1820 courthouse, Pilgrim Hall and Memorial Hall to the traffic lights at the 3A/44 (Court Street and Samoset Street) intersection. Passing through the intersection, we take the first left onto Cushman Street. Taking a right on Allerton Street at the top of the hill, we come to Forefathers' Monument.

38: FOREFATHERS' MONUMENT

The National Monument to the Forefathers is the largest freestanding granite statue in the world. Situated on a hill overlooking the harbor on Allerton Street, the Pilgrim monument was completed in 1889. It is eighty-one feet high, and "Faith," the principal statue, is thirty-six feet tall. In addition to Faith, there are four fifteen-foot seated supporting statues: "Morality," "Education," "Freedom." and "Law." There are also four upright panels and eight marble bas-reliefs with various Pilgrim scenes. The entire memorial cost about $125,000 (in nineteenth-century dollars—about $2,712,500 today).

When the Pilgrim Society was founded in 1820, part of its stated mission was to erect a monument to the Pilgrim Forefathers. Pilgrim Hall was finished by 1824 but no progress was made on the monument until almost thirty years later. In 1853, the society held an immense celebration, considering the time and place, to publicize the goal of funding an appropriate monument to the Pilgrims. A competition was held and the winning designers, Hungarian artists Zucker and Asboth, won a $300 prize, but a tardy proposal by Hammatt Billings of Boston was accepted as the actual plan for both a massive Pilgrim monument and a memorial portico over Plymouth Rock.

The cornerstones of both structures were laid with much ceremony on August 2, 1859. The Plymouth Rock portico, a granite structure fifteen square feet by thirty feet high of the Tuscan architectural order, was completed by 1867 and had in its upper story the bones of four Pilgrims, which had been discovered (while digging a sewer) on Cole's Hill in 1854. The canopy only contained the lower half of the famous rock (which was level with the floor of the structure) until 1880, when the two segments were reunited. This structure was demolished in 1919 and replaced with the present portico by McKim, Mead and White.

The stone for Forefathers' Monument was imported from Maine—the forty-five-foot pedestal from the Bodwell Granite Company in Vinalhaven and the statuary from the Hallowell Granite Company of Hallowell. The monument was dedicated on August 1, 1889. Downtown Plymouth was decorated with ceremonial arches and many private houses were also decked with flags, boughs and other decorations. A grand parade was held and the dedication was performed during a Masonic ceremony, with the usual formal dinner of the period including orations and addresses following the event. In 1989, the monument was rededicated after extensive repair and restoration with a parade and ceremony addressed by John Talcott and Reverend Peter Gomes. Because of vandalism and similar problems, the entrance to the monument grounds has been closed to vehicular traffic, but tourists may still stroll around the massive statue and consider both the Pilgrim story and what significance its values held for nineteenth-century America that it should inspire such an impressive memorial to the national memory.

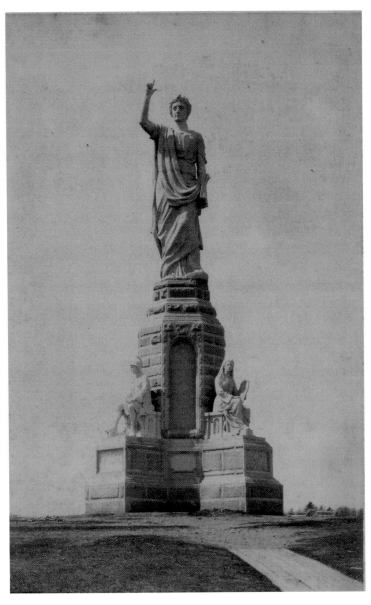

Forefathers' Monument, circa 1900. The eighty-one-foot-high granite memorial to the virtues attributed to the Plymouth Forefathers, better known as the Plymouth Pilgrims.

Leaving Monument Park, we continue on Allerton Street (which turns sharply right) to the intersection with Court Street. Take the second right (after the shopping center) onto Nelson Street. The northern boundary of Plymouth's 1623 planting field division is today Nelson Street, at the foot of which is the pleasant seaside Nelson Memorial Park.

39: NELSON MEMORIAL PARK

Nelson Park is a small public park at the northern end of Water Street. Originally established about 1920 to serve the new generation of automobile campers, the seaside park is now greatly favored by local families who enjoy the harbor-side venue. There are playing fields, a playground for youngsters and (during the summer season) a refreshment stand with restrooms. At the northern end of the park, a road leads to the abandoned Old Colony Railroad bed, on which there is a scenic paved path extending almost to the grounds of the former Plymouth Cordage Company (where the commuter rail line to Boston ends today). The path passes the twenty-six-acre Holmes Reservation Field, donated to the Trustees of Reservations in 1944. The path continues by a wooded hillside area called High Cliff, near where the Prence and Billington families had farms in the seventeenth century.

40: NORTH PLYMOUTH

North Plymouth expanded to support the Cordage Company, and Court Street here provides as full a community center as downtown Plymouth. Many of the inhabitants are children and grandchildren of the German, Irish, Portuguese and Italian immigrants who came to work in the rope factory. One unusual historical site in North Plymouth (west of High Cliff on Court street) is Suosso's Lane, where Italian anarchist Bartolomeo Vanzetti was living at 6 Suosso's Lane when he was arrested in 1920 before the famous Sacco and Vanzetti trial. Woody Guthrie wrote a song about the lane (which he called "Suassos" Lane) in 1945. Vanzetti had worked for the Plymouth Cordage Company before he took a trip to Mexico to avoid being drafted; he resigned to work on the Plymouth waterfront breakwater and as a fish peddler. Sacco and Vanzetti were arraigned and tried for their alleged participation in the robbery of the Slater & Morrill Shoe factory's payroll and killing of the shoe factory paymaster and a security guard in South Braintree, Massachusetts, on the afternoon of April 15, 1920. A highly contentious trial with a patently bigoted judge, Webster Thayer, as well as contemporary bias against both immigrants and anarchism, resulted in a guilty verdict that historians have been arguing about ever since. In 1920, factions of the international anarchist movement were as well known for their "attendats" (political assassinations) and terrorist activities as militant Islamists and Al Qaeda are today. Sacco and Vanzetti were executed despite international protest in 1927, yet nearly all subsequent investigations attest to Vanzetti's, if not Sacco's, innocence. Passing Suosso's Lane, we continue north until we see the former Cordage Company buildings on our right at a traffic light.

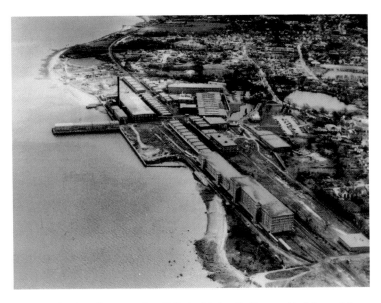

Plymouth Cordage Company, circa 1945. Aerial view (looking south) of the world's largest manufacturer of rope and twine, in North Plymouth.

41: PLYMOUTH CORDAGE COMPANY AND MUSEUM

The Plymouth Cordage Company was founded by Bourne Spooner on June 12, 1824, with $20,000 capital raised from local and Boston merchants. Spooner had learned the art of cordage making in Louisiana, where he had also observed the inhumanity and inefficiency of the slave-manned ropewalks of New Orleans. Returning to Plymouth a trained rope maker and a fervent abolitionist, he secured two mill privileges on Nathan's Brook in "Bungtown," as the north district of Plymouth was then known. The company grew slowly (its main offices were in a remodeled gristmill for many years). By March 1825, production began at the main ropewalk, which was 1,050 feet long and built from lumber imported from Maine. After the great fire of January 3, 1885, the old mill was replaced with the handsome Mill #1 in 1893. In 1899 the Mill #2 was added, and Mill #3 in 1907. The Cordage Company became not only Plymouth's largest employer for many years but also the largest rope manufacturer in the world. The thousands of immigrants the company attracted from Germany, Ireland and Italy permanently changed the makeup of Plymouth's population.

However, as demand for rope declined after World War I, the company fell upon hard times. Strikes and unionization as well as pressure from outside trusts and combinations led to the sale of the company to Columbia Rope in 1965, and in 1969 Plymouth Cordage Company ceased production forever, putting 149 employees out of work. Today,

the old mill buildings are being put to new uses, and a new museum opened in 2005 beneath the tower of Mill #1, in which are collected some of the products, machinery and records of Plymouth Cordage. Admission is free, as is parking. There are other offices and stores in Mill #1 and Mill #3, which are connected by a covered walkway. Walking over scarred floors through the wide corridors, which still bear the scent of pine tar used on the rope products, the visitor is struck by the size and sturdiness of the old factory. Several huge warehouses still exist, mostly in ruinous conditions, as are Mill #2 and the old wharf facilities—all of which provide an impressive glimpse of what was once Plymouth's most important manufacturing enterprise.

Having reached the town's northern boundary with Kingston, we now begin our southerly tour, again starting from Town Square. We drive south across the Main Street Extension Bridge that spans Town Brook; we join Sandwich Street (which comes in from the right) as it runs past the Training Green and the streets we visited on the "T'other Side" Walking Tour. We soon come to a scenic harbor view across Hobshole meadow or salt marsh.

42: HOBSHOLE OR WELLINGSLEY

Plymouth's oldest separate neighborhood is noted in the colonial records variously as "the Little Town," "Wellingsley" and "Hobshole." The origin of these names has been lost. "Hobshole"—a name used as early as 1623 for the salt marsh and the brook that flows into it—marks the northern border of the neighborhood. "Hobshole" may refer to either the knobby tussocks in the marsh or perhaps someone named Robert—"Hob" being an old nickname for Robert. Robert Bartlett and Robert Ratliffe both had land south of Hobshole Brook in 1623. There has been speculation that "Wellingsley," first mentioned in 1639, might derive from a hamlet called "Wellingley" in England near Scrooby on the Yorkshire-Nottinghamshire border, where the Bradford and Morton families originated. Governor Bradford's great-grandfather "Robert Bradfourth, of Wellingley, Tickhill, York, England" (circa 1487–1553) came from there, and his nephew Nathaniel Morton later settled on the north side of Hobshole on Wellingsley Brook. There are still a number of seventeenth- and eighteenth-century houses on Sandwich Street as it passes through the Hobshole neighborhood. The old schoolhouse is now a storage facility for Bradford's Liquor Store and the former Union Chapel has also been incorporated into the store building. Across the street the Corner Store has been in operation since the late eighteenth century, the original structure (with some twenty additions over the years) having been built by Jabez Churchill Jr., from whom the name "Jabez Corner" that applies to the area is derived.

Years ago, the residents of Hobshole were thankful that the prevailing summer breezes blew from the west. You could always tell when an onshore wind kicked up, for a very powerful scent of fish came wafting up from the shore where the fish flakes stood. These were waist-high platforms built with a "wattle" top, a matting of sticks and boughs woven together. The flakes supported hundreds of split codfish drying in the sun whose perfume declared the neighborhood a fisherman's habitat, without question. There were also small buildings in which the fish could be stored in wet weather and two wharves—Morton's Wharf below the Hobshole House and Tar Landing near the entrance to Hobshole meadow.

The best salt cod, the neighbors averred, was "dunfish," a reddish-brown dried cod, and the only person in Plymouth who could properly cure them in this fashion was Deacon John Hall, who lived at the other end of town on the corner of Hall and Court Streets. To make dunfish, cod were caught in the spring, gutted, headed, split, slack-salted (very lightly salted) and when partially dry, piled in a dark hut and covered with seaweed. They had to be re-piled after several weeks and left for a few more weeks before they were eaten. Salt cod, dun or other, was enjoyed by many a Plymouth family as "salt-fish dinner." It was served boiled with potatoes, beets, carrots and onions, and then sprinkled with pork scraps (bits of chopped salt pork, fried), oil (the liquid fat from the salt pork or olive oil) and salt and pepper.

Going through the traffic lights at Jabez Corner (where Sandwich Street turns to the right) onto Warren Avenue, we pass a number of elegant "summer cottages" built in the late nineteenth century. In 1850 Warren Avenue was opened along the shore. Earlier, Sandwich Street went inland, following Indian trails that avoided having to cross several brooks and wetlands on the harbor shore. Just before we reach Plymouth Beach on the south side of Eel River, we come to the entrance of Plimoth Plantation.

43: PLIMOTH PLANTATION

The greatest contribution to the Plymouth tourist experience since the installation of the massive Victorian National Monument to the Forefathers has been Plimoth Plantation, the living history museum of seventeenth-century Plymouth. Since it's founding in 1947, Plimoth Plantation has brought the past to life for millions of visitors in search of Plymouth's colonial and Native American heritage. Plimoth Plantation began as a memorial to the Pilgrims that reflected the popular representation of American history just after World War II. Unlike its regional contemporaries, such as Old Sturbridge Village or Shelburne Museum, Plimoth Plantation was not founded to display material culture collections or to preserve the (relatively) recent New

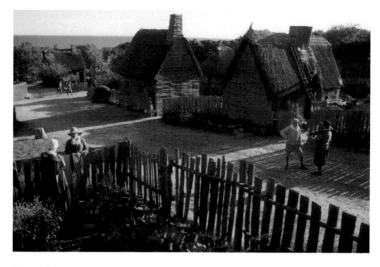

Plimoth Plantation. The "Pilgrim" or "English" Colonial Village, a re-creation of the "Streete" (today's Leyden Street) as it appeared in 1627.

England past. Similarly, the Pilgrim community was not reconstructed after the manner of Colonial Williamsburg or Old Sturbridge Village, as no buildings and only precious few artifacts survived from early seventeenth-century Plymouth. Those objects that had survived, whether preserved in Pilgrim Hall or found in archaeological excavations, could not be cared for in an outdoor museum, so the plantation used generic antiques and modern reproductions to create a sense of the past.

The museum quickly became popular, especially at Thanksgiving time, the holiday that was inextricably associated with the Pilgrim story in the 1930s and '40s. Employing mannequin displays representing famous 1620s events and the familiar crafts demonstrations typically found in New England house museums and decorative gardens, the early Pilgrim Village perpetuated the popular image of the Pilgrims while avoiding the mythic excess surrounding the landing on Plymouth Rock, the "Courtship of Myles Standish" or the First Thanksgiving. Tourists to Plymouth found the familiar Pilgrim story they had learned as youngsters well represented at Plimoth Plantation and aboard *Mayflower II*.

Yet when the postwar social consensus broke down in the 1960s and alternative views of history became popular, Plimoth Plantation was in a position to move with the times (or even ahead of them). The museum relied on admission revenue rather than endowment or donations for its operations, and this allowed the professional staff greater latitude in determining the direction of the institution. The earlier emphasis on the Pilgrims' contributions (real and imagined) to American culture was replaced by social history and a careful attention

to the historical context surrounding the immigration and adjustment to the New World by the Plymouth colonists. Instead of concentrating on the "Pilgrim" (a late eighteenth-century name for the Plymouth colonists that has come to embody their symbolic virtues) story, Plimoth Plantation used anthropological methods to represent the daily life of the early New England colonists. The visiting public greatly enjoyed the combination of historical exhibits and increasingly more accurate interpretation by the costumed staff.

In 1969, the museum took a dramatic step toward greater seventeenth-century verisimilitude by adopting the new "living history" approach of historical interpretation. All of the older museum display techniques such as mannequins, signs, static displays and repetitive demonstrations were removed. The antiques were sold to pay for better reproductions and the Pilgrim Village was made to function more as a living agricultural community by adding livestock and period farming methods. The Indian Camp was moved from the Pilgrim Village site to the banks of the Eel River and staffed with local Native Americans.

The abrupt changes were highly controversial among the plantation's traditional supporters, who were fond of the old familiar didactic exhibits. Even the popular annual Thanksgiving observation was dropped as anachronistic. But attendance continued to grow and the visiting public found the new approach exciting. In 1978, the museum introduced a "first person" role-playing method of interpretation, which made the visitor experience even more engaging and real. There was still much to do to improve the quality of the re-creations and activities, but Plimoth Plantation had successfully "reinvented" itself for a modern audience. The construction of an impressive new visitor center in 1987, the decision to gradually replace all of the older reproduced houses, an exemplary rare breeds program and the return of *Mayflower II* to sailing condition all helped the plantation to attract increased visitation at a time when outdoor museum attendance was stagnant or falling elsewhere. Tourists from around the world came to see the painstaking re-creation and fell in love with its uniquely engaging "journey back in time."

As public amusements, theme parks and museums spring up in ever-increasing numbers across America, the competition for leisure time and money has become intense, yet the plantation continues to prosper. Plimoth Plantation is recognized as a leader in the living history experience and a model for visitor interaction and involvement. Once, serious tourists had to carry the entire Pilgrim Plymouth story in their heads and imagine what it had been like centuries ago as they walked the streets and lanes of the modern community. Today Plimoth Plantation offers a highly accurate and stunningly impressive window to the past for everyone to experience "the way it was" when two diverse cultures, English and Wampanoag, met at the daybreak of America.

The Wampanoag Homesite. A re-creation of the farm occupied by Hobbamock, a leading "pinese" or Wampanoag warrior/councilor who lived across Town Brook from Plymouth Village before moving to Duxbury.

Plimoth Plantation has grown from modest beginnings to incorporate the present "English Village" (actually a colonial one, but the term "Pilgrim" did not come into use until about 1800), the "Wampanoag Homesite" (with dwellings of a seventeenth-century Native family), a crafts center where reproductions for both sale and use in the exhibits are made and a visitor center where there are orientation theaters, an exhibit gallery, dining facilities and museum shops. At present, the institution is pushing a "bi-cultural" experience (i.e., balanced between colonial and Native) that, while laudable in principal, tends to be more determined by modern social imperatives than objectively interpreting the past. Nevertheless, the plantation is a wonderful and evocative venue where Plymouth's history can be engaged for hours at a time on both a sensual and a cognitive level. A visit to Plimoth Plantation will yield more appreciation of colonial history than most elaborate name-fact-and-date approaches by other institutions.

Leaving Plimoth Plantation by the lower or westerly gate onto River Street, we turn north until we come to an old white wooden New England church, with an extensive graveyard behind it that borders the plantation parking lot.

44: CHILTONVILLE CHURCH

North of Plimoth Plantation's west exit on River Street is the Chiltonville Church (Congregational), built in 1840. Although the first independent church for this area (originally called Eel River Village)

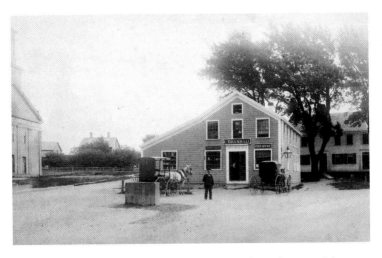

Bramhall's Store, Chiltonville, circa 1885. The old general store, just west of the Chiltonville Church, still operates each summer selling ice cream and fresh local produce.

was not established until 1818, the extensive graveyard behind the church was first used in the eighteenth century. The earliest surviving stone is that of Captain Ephraim Morton, dating to 1729. The original colonial road to Cape Cod followed River Street and crossed Eel River where the small River Street bridge is today. The present Sandwich Road now separates from the older route at Bramhall's Corner in Chiltonville near the church.

Religion was a controversial topic in Plymouth during the 1820s when the church was new. Despite differences between the Unitarian and Trinitarian factions in the Congregational church, Reverend James Kendall of Plymouth's First Parish Church was well liked and respected enough to be invited to exchange pulpits with his evangelical counterpart at Eel River Village (now more decorously know as Chiltonville), Reverend Benjamin Whitmore. After the service, two of the local parishioners were overheard discussing the service.

"Well, Captain, how did you like the parson?"

The Captain replied, "I don't take much to this one God doctrine."

"I guess," said the other, "one God is enough for Eel River, they only claim three in Boston."

Passing the church and proceeding north to the next right, we turn onto Cliff Street and pass a number of quaint Plymouth houses from all periods before turning right back onto Warren Avenue (3A) again. Just past the Plimoth Plantation entrance over the Eel River bridge, we see on our right the parking lot at the foot of Plymouth Beach.

Plymouth Beach. Plymouth's three-mile-long sand spit is tremendously attractive to locals and visitors alike on hot summer days. The large object in the sky is the Goodyear blimp.

45: PLYMOUTH BEACH

One of Plymouth's most attractive amenities is the three-mile-long barrier beach that joins the mainland at the southern end of the harbor, across from the entrance to Plimoth Plantation. Residents and visitors can enjoy the (cold) waters of Cape Cod Bay or walk along the sand to the tip, even though the bird sanctuary there amid the dunes is off-limits to intruders. There is sufficient parking at the entrance to the beach, although anyone without a resident sticker is charged. There are also two places to eat here, a good sit-down restaurant and an informal, seasonal "snack bar" on the beach itself.

Today Plymouth Beach is a bare three miles of dunes and granite breakwater, sparsely vegetated by dune grass and low scrubby plants, but before the American Revolution it included a pleasantly forested area near the turn of the channel. On the inner side of the beach there were extensive wild plum and wild cherry bushes, not to mention beech and pitch pines in one swampy area. Dr. Thacher (1832) notes that there had been a favorite picnic spot for leisured Plymoutheans, a "spot about 50 feet square" covered with grass amongst the trees hung with wild grape vines. Unfortunately, even back then mankind was inclined to create ecological problems. About 1750 a group of farmers on Eel River made or enlarged a cut through to the sea from the pond now south of Plimoth Plantation into Warren's Cove. This made it easier for them to bring their produce to market, but it also stopped

the flow of water into the harbor. By thus changing the currents, the new mouth of the river led to the decline of the beach.

By 1764, the sea had broken through the beach in two places, which were enlarged by a storm in 1778. In 1784, a great storm killed all of the trees. Marine engineer John Peck told the town of Plymouth that the diversion of Eel River was the cause of the problem and that the construction of a canal diverting the river back into the harbor was "indispensable," but in the manner of Yankee towns, nothing was done once the expense was estimated. The tide was actually sweeping over the length of the beach by 1806, and all attempts to lay stone breakwaters or replace the sand proved futile. The Commonwealth of Massachusetts spent over $40,000, raised by selling two townships in Maine (then part of Massachusetts) and a lottery, to little avail. In 1814, a canal a half-mile long and fifteen feet wide was cut to redirect the river into the harbor once more. The federal government sent engineers and funds in the 1820s to repair the beach. The gaps were closed and the beach restored to its full length, but the bosky groves where picnickers once gathered wild grapes were lost forever.

46: ROCKY HILL ROAD AND MANOMET BEACHES

Heading south on 3A we pass the site of the old Hotel Pilgrim on the ocean side at the crest of the hill above the Pilgrim Sands Motel, where the new condominiums are now. The hotel, which opened as the Clifford House in the 1850s, was one of Plymouth's finest until it closed in the late 1950s. Beyond the overpass where the "M Road" (the connector to Route 3 North) joins 3A, we take a left onto Rocky Hill Road. This road, like Warren Avenue, was built for summer visitors to access several estates at the end of Rocky Point, where the Pine Hills meet the sea. The Pine Hills are a glacial feature forming a gigantic ridge, four miles long north and south, and almost four hundred feet high. We owe the beautiful Pine Hills landscape to the action of the last great glacial ice sheet to cover New England during the Wisconsinian period 25,000 years ago. The characteristic knobby hills ("kames"), rounded valleys and ponds ("kettle ponds") and relatively infertile soil are typical of landscape shaped long ago by glacial action. The region's original topsoil and bedrock (there are no outcrops of the bedrock farther south than Kingston) has been covered by one to three hundred feet of sand and stones left behind when the ice sheet retreated. The Pinehills development, three thousand acres in extent, on the west side of the ridge was the private Symington/Talcott estate until 1982.

After the road turns south around the end of the point, signs indicate the presence of the Pilgrim Nuclear Plant. Built in 1972, the plant had a dramatic effect on local property taxes, and along with the completion of the new limited access Route 3 to Cape Cod, spurred a development surge that tripled Plymouth's population in thirty years.

White Horse Beach. Located south of Plymouth Center in Manomet, the White Horse Beach cottage community has been a popular vacation resort since the late nineteenth century.

Further along Rocky Hill Road is the old summer colony of Priscilla Beach and the Priscilla Beach Theatre founded by Franklin Trask in 1937, the oldest barn theater still in seasonal operation. Many of the cottages are now year-round residences. At the end of the road, we turn right on to White Horse Beach Road and return to Route 3A (at the traffic lights). If we had turned left toward the ocean, we would have come to White Horse Beach, another larger summer colony. Along Tayor Avenue on both sides of Bartlett Pond, White Horse Beach is a classic example of an early twentieth-century beach community. The beach is associated with a popular legend of dubious antiquity about a woman named Helen who rode a white horse into the sea, never to return. Her ghostly presence is thought to be seen at times on the large boulder just offshore from the beach. "Helen of White Horse," a poem written by Reverend Timothy Paine circa 1890, relates how a local farmer forbade his daughter Helen to marry her lover, Roland, which precipitated her "suicide by horse." Over the years, the story has been embellished and is now oddly associated with the wreck of the *General Arnold* in 1778. Helen became the daughter of a "Dr. Paine" who nursed a survivor of the wreck named Roland Doane, and when her father forbid her to marry him, Helen mysteriously rode off into the sea, only to apparently return on suitably atmospheric days. There is no apparent historical basis for Helen or her act of desperation, but the specific date in the original poem of August 24 was discovered by Herman Hunt to be the day that Reverend Paine's infant son Joseph died in 1861.

Manomet Church, circa 1890. This simple New England meetinghouse, built in 1726 for the widespread Manomet farming community, is Plymouth's oldest house of worship.

47: Second Church, Manomet

On the corner of White Horse Beach Road and State Road (3A) is the venerable Manomet Church. The Manomet Ponds neighborhood was settled in the early eighteenth century, and the second church of Plymouth (earlier divisions being in what later became separate towns such as Duxbury, Kingston and Plympton) was established in 1738. The present church was built in 1826, whereas the first had been located farther east on the south side of White Horse Road. The church was the first south of town, and people from Chiltonville to Ellisville traveled here to attend services, some even having to stay with friends from Saturday night to Monday morning. The oldest stone in the graveyard (Benjamin Bartlett) dates to 1717. It was a good Yankee congregation, coming out against slavery in 1853. The expenses of the church, from about 1681 to 1871, were paid for through the sale of fishing permits to catch herring in the local brooks.

The first ventures south of the Pine Hills occurred in the 1630s, and by the early eighteenth century, the little dispersed Manomet Ponds community extended as far west as Old Sandwich Road.

Continuing on 3A, we take a right onto Brook Road, one of the oldest Manomet residential streets.

PLYMOUTH 27TH OF AUG 09 - FAMILY CRADLE FOUND IN THE OLD BARTLETT HOUSE BUILT IN 1680.

Bartlett family homestead. This old house is very typical of the farmhouses built toward the close of the seventeenth century in the Plymouth area. It is an unmarked private residence today.

48: THE BARTLETT HOUSE

The Brook Road neighborhood also goes back to the seventeenth century. There were a number of Bartlett family homes in the area (one seventeenth-century example just burned down a few years ago), but the unofficial late seventeenth-century family homestead (as depicted in a family reunion picture from 1909) still exists. It is on the east side of the road after it crosses Bartlett Brook, on a slight rise above the road. This area was once all farmland and largely treeless, but today the forest has returned, threatened now by new housing rather than agriculture or the need for firewood.

We then come back out onto 3A near a supermarket. Up the hill to the right there is an intersection with Manomet Point Road, which will take the visitor to the southern end of the White Horse Beach and the cottages on Manomet Point. The cottages, once used by summering families, have today in many instances become year-round residences and condos. This area has long been associated with vacationers—first sportsmen looking to fish, shoot and sail in the 1820s, then summer visitors after the Civil War, for whom a series of boardinghouses and hotels were maintained until the 1970s, including F.H. Holmes', the Ardmore Inn and the massive Mayflower Inn. The old coast guard station #13, built in 1874 at the tip of Manomet Point, was where rescue attempts for the *Robert E. Lee* steamer in March 1928 led to the loss of three men. It was closed in 1947. Continuing on 3A as the road takes a sharp bend to the left, we come to Fresh Pond.

49: FRESH POND

An Indian reservation of two hundred acres was established on the south side of the pond in 1712. As the indigenous inhabitants died or moved away, one hundred acres were sold in 1800, and the remainder dispersed at a later date. Fresh Pond was for years the southern end of the Brockton and Plymouth Street Railway line. The electric trolley system, invented by Frank Sprague in 1888, was introduced in Plymouth in 1889 when the Kingston and Plymouth Street Railway opened for business. The original line ran between Jabez Corner and Cobb's store in Kingston, near Rocky Nook. The fare was ten cents over the entire line, and a nickel from either end to or from the center.

The line was later extended south to Plymouth Beach and the old Clifford House hotel, which was bought and renamed the Hotel Pilgrim by the Kingston and Plymouth Street Railway in 1891, and to Kingston Center in 1893. The hotel was sold again in 1903. The extension to Fresh Pond was opened as the "Plymouth and Sandwich Street Railway," a separate line, in 1899. The Plymouth and Sandwich line operated between the Hotel Pilgrim and Fresh Pond, about six miles south on today's Route 3A. The intent was to continue service south to Sandwich on Cape Cod, although that never actually happened. Although tracks and overhead feed wire were extended to Sagamore by 1916, they were never put into service, and the company went out of business in 1918. The tracks south of Fresh Pond were sold for scrap and removed in 1920, and the portion between Hotel Pilgrim and Fresh Pond was closed in 1921. The company switched to motorized buses in 1928. There was also a public auto-camping park here in the 1920s—the sister park to the one on Nelson Street. There is a small public beach here where parking and restroom facilities are available at no cost.

We continue south on 3A past Indian Brook and through "Vallersville," where Ship Pond can be seen on the left or bay side, until we arrive at Ellisville. Although there are no public buildings here, there is a very pleasant (and relatively new—1991) public recreation spot, the Ellisville Harbor State Park. There is free parking and 102 acres of woodland, upland meadows and bogs. A network of trails overlook salt marshes that surround the harbor, and on the Cape Cod Bay side, there is a rather rocky barrier beach with a wonderful view of the bay and of Sandwich on the far side of the Cape Cod Canal.

Just south of the entrance of the park we take a left turn on to Ellisville Road. Before the present stretch of 3A was opened up the hill in 1898, this was the original route of the old road to Sandwich.

50: ELLISVILLE

The last stop north of Sandwich in Plymouth's stagecoach days on the Old Sandwich Road was at the Ellisville tavern. Public transportation

in Plymouth began with the introduction of stagecoach service to Boston and Sandwich by Dr. James Thacher and his brother-in-law Dr. Nathan Hayward in 1796. The original stage coaches were not the familiar western-style coach, but a long covered wagon hung on leather through-braces containing seats without backs, which were reached by climbing over the seats in front.

The Ellis family had owned land here near the shore since John Ellis acquired his property in 1658, and the Ellis Inn was the traveler's first stop north, followed by Cornish's Tavern about six miles up the old road. The inn, known locally as the "Hiram Ellis's" house, is on the right or inland side of the road, just beyond the salt pond and Slough Road. Thoreau stopped at Ellisville in June 1857 on his way to Cape Cod:

> *I put up at Samuel Ellis's, just beyond the Salt Pond near by, having walked six or seven miles from Manomet through a singularly out-of-the-way region, of which you wonder if it is ever represented in the legislature. Mrs. Ellis agreed to take me in, though they had already supped and she was unusually tired, it being washing-day. They were accustomed to put up peddlers from time to time, and had some pies just baked for such an emergency…Mr. Ellis, an oldish man, said the lobsters were plentier than they used to be, that one sometimes got three hundred and upward in a day.*[*]

Ellisville Road rejoins State Road (Route 3A) a mile or two to the south. The next community we meet toward Cape Cod is Cedarville. The present civic district, with its supermarket, fire station and shops, is on the eastern side of Route 3 near exit 2, but the historical center is on the west side of Route 3, where Herring Pond Road meets Long Pond Road. Look for the traditional "Little Red Schoolhouse" near the junction with Long Pond Road.

51: CEDARVILLE AND GREAT HERRING POND

Like Fresh Pond, Great Herring Pond was the site of an Indian reservation. In 1803 the state set aside 2,683 acres around the large pond for the Herring Pond Wampanoag families, who lived here until the 1870s when they began to abandon the land and sell it to non-Indian families. There are still some Indian families in the town.

Cedarville also figured largely in the controversy over Sarah Pratt McLean's novel, *Cape Cod Folks* (1881), as it was the model for "Wallencamp," depicted as a backward community of quaint and colorful survivors from another age. This was one of the first Cape Cod local color stories, a genre that became very popular around the

* Bradford Torrey, ed., *Writings of Henry David Thoreau, Journal* (Boston: Houghton, Mifflin, 1906), 9:422.

turn of the twentieth century at the hands of more facile writers such as James A. Cooper, Sarah Ware Bassett and particularly, Joseph C. Lincoln. The problem was that while Miss McLean fictionalized the name of the community, she used the real names of people she had met in Cedarville (or Wallencamp) and also described them clearly enough that the originals could easily recognize themselves in the fictional caricatures—and they didn't like it! While readers found the peculiarities of the "authentic Cape Codders," somewhat exaggerated for effect, amusing and engaging (O.W. Holmes very much liked the book), Cedarville residents very much resented the implication that they were odd, out-of-touch dialect-speakers. Then a Boston lawyer, Benjamin R. Curtis Jr. (son of a Supreme Court justice, who had a summer home in Plymouth on Warren Avenue, later bought by Harriet Hornblower and today the site of the Plimoth Plantation fort/ meetinghouse) created a dramatic version of the story for the Papyrus Club, a Boston literary society, stressing the comic aspects and further incensing the originals. Sarah Pratt McLean (later Greene) quickly apologized and the names were changed in subsequent editions. Four years later, Lorenzo Nightingale (who was the model for Lute, the hero of the story) sued McLean's publisher and was awarded $1,095.

Route 3A continues on to the Sagamore Bridge, but we will cease our tour at the town's southern boundary with Bourne. Plymouth stops just short of the Cape Cod Canal, which bisects the towns of Sandwich, Sagamore and Bourne. Today, Cape Cod may start for us two miles to the south where the canal cuts off the Cape from the rest of the commonwealth, but in truth, Cape Cod begins both geologically and culturally at the Pine Hills, if not with all of Plymouth.

Before we leave old Plymouth, however, there are a few other sites worthy of note.

52: PARTING WAYS
A Northern Byway

A unique historic site can be found west of downtown Plymouth on Route 80 near the Plymouth/Kingston line. Four young African American men—one a free man, two former slaves and one who fought for his country's liberty while he himself was enslaved—were allowed to settle on town land following the American Revolution. The Town of Plymouth granted these four African American veterans and Patriots land in an area known as Parting Ways. The "New Guinea" settlement they founded survived into the early years of the twentieth century.

To visit the Parting Ways site, leave Town Square by Market Street and turn right up Summer Street. Continue west past the Vine Hill–Oak Grove Cemetery, over Route 3 and through the traffic

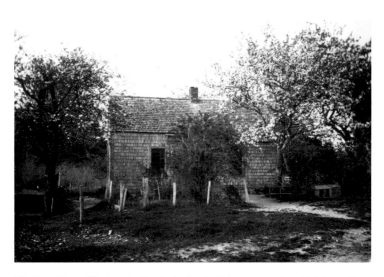

The Burr House. The last dwelling in the Parting Ways community, which burned in 1908. The graves of the four black Revolutionary War veterans who lived here are marked and well tended.

light at Pilgrim Hill Road. There is a steep valley just after the traffic light (Witches' Hollow), and at the crest of the far side at Sparrow's Hill, turn right onto Carver Road. At the next light (a three-way intersection) continue west and take your first right onto Route 80. Parting Ways is one and a half miles on the right, just before the intersection with the Plympton Road where Route 80 makes a ninety-degree turn to the right at the Sacred Heart School.

The original inhabitants, Cato Howe, Plato Turner, Prince Goodwin and Quamony Quash are buried at Parting Ways. Their graves, marked with American flags, can be seen in a small enclosure on the north side of Route 80, and there is a trail through their former farmland (now reverted to its natural state), which originally extended to all three sides of the roads at the intersection. The site is listed on the National Register of Historic Places.

Cato Howe enlisted at the age of twenty-five and served in Colonel Bailey's Twenty-third Continental Infantry, and later in Colonel Theophilus Cotton's Plymouth militia regiment. Howe fought at the Battle of Bunker Hill and was discharged in 1783. Quamony Quash enlisted at the age of seventeen in Colonel Cotton's, and later Colonel Bailey's, regiments. Prince Goodwin enlisted but spent only three months in the military. Plato Turner was twenty-eight when he enlisted and became part of Bider's and Colonel Theophilus Cotton's regiments.

Cato Howe was conditionally granted approximately ninety-three acres of land in Plymouth on what is now Route 80 (Plympton Road) in

March 1792. The four men cleared the property for farming and lived there with the town's permission. Howe died in 1824, but descendants of some of the men lived on the site into the early twentieth century, after which the abandoned land reverted to the Town of Plymouth. Archaeological excavations conducted by Dr. James Deetz in 1975 and 1976 provided valuable historical evidence and information about the settlement's extent and layout.

53: OLD SANDWICH ROAD
A Southern Byway

Many Plymoutheans are quietly proud of the old road to the Cape that has until recently seen very little development. In fact, some long stretches are still unpaved, just as they were a century ago. The colonial town of Sandwich was not an offshoot of Plymouth, but was settled by immigrants from the Massachusetts Bay Colony. Families from Lynn and Saugus as well as Duxbury and Plymouth incorporated Cape Cod's first town in 1639. Once Sandwich was established, there was a need for communication and commerce with Plymouth, fifteen miles north. At first the colonists used various Indian trails through the "pine commons" that separated the two towns. In 1652, the Plymouth General Court empanelled a jury to choose and lay out the best possible route between the towns, which had to be cleared sufficiently to allow a man and a horse to travel it. The first description of the road from Sandwich in the colony records is a bit vague: "Beginning att Sandwich, and soe leaving Goodman Blackes house on the right hand, running crosse the swampe ouer the riuer, and soe vpon a nornorth west line soe falling vpon the Eelriuer, where two great trees of spruce lye ouer the riuer."

Two spruce trees were not a satisfactory bridge, but Plymouth had trouble getting the Cape Cod towns to pay for building a bridge over Eel River, whatever the benefit for them. The road did not follow the modern route along the right fork at Bramhall's Corner, but took the left fork at the corner onto today's River Street. It crossed the first Eel River bridge and followed Clifford Road west before turning south on Doten Road, and then took the old Lister Road, joining the present Old Sandwich Road just south of Swan Bridge (the stone bridge across Forges Brook). Sandwich, Barnstable and Yarmouth were also slow in paying for the 1650s bridge, but it too was eventually built, and the way to Sandwich was surveyed and cleared to become the Old Sandwich Road we know today—more or less. The Commonwealth of Massachusetts has recently installed a new River Street bridge.

Sandwich Street becomes the Old Sandwich Road at Bramhall's Corner, after which it crosses the "M Road" extension from Exit 4,

Sacrifice Rock. The "Asseinah Manittoo," the "Plymouth Rock" of the local Wampanoag people, now belongs to the Plymouth Antiquarian Society.

Route 3 south, and continues through the Chiltonville neighborhood. At Four Corners (where the road meets Clifford and Jordan Roads), we see the fields that were once part of the estate of Eben Jordan Jr., son of the founder of Jordan Marsh Co. in Boston. We then enter a white pine forest that marks the beginning of the Pinehills development area.

54: SACRIFICE ROCK

On the eastern side of Old Sandwich Road (on the south corner of Sacrifice Rock Road) is a moderate-sized boulder with a small marker stating that it is an "Asseinah Manittoo" or "Sacrifice Rock." If the Pilgrims have their Plymouth Rock, so too do the Wampanoag Indians have their granite memorial and shrine. The English name sounds melodramatic at first, conjuring up images of bloody rituals, but it is an accurate descriptor of the rock's religious importance to the Wampanoag. The sacrifice itself was modest—the Indians paid homage to the spiritual forces associated with the boulder by dropping a simple branch with green leaves as they passed on their way between Sandwich and Plymouth, just as stones are dropped on cairns or heaps in less wooded regions of the world. There are two other "sacrifice rocks" farther south on Old Sandwich Road, and others in the neighboring town of Bourne.

The Cornish Tavern. Built by Josiah Cornish in 1792, the old tavern has recently been renovated and is again serving travelers, with the cuisine of Martha Stone, a renowned local cook—but no beds for a night.

It isn't possible to accurately explain the significance of "manittoo" or manitou, the Indian's sacred force, in a brief space, but roughly it encompasses the spiritual power and relationships that pervade the world in addition to referring to the hazily personified "Great Spirit," the common translation of the term. This spiritual current, which might be understood as analogous to the classical "pneuma," exists everywhere, but it is found in a more concentrated manner in certain people, places and things. A sacrifice rock was a place where the "manittoo" was particularly strong and therefore deserved recognition and veneration (if not worship in the Western sense). The deposit of living green branches was the traditional way to respect this presence, much as the atavistic compulsion to toss coins in springs (or on Plymouth Rock) that survives in our culture.

After a hundred yards or so the road turns to dirt, although there is a paved road (Stonebridge Road) to the right that the development has opened to allow drivers to avoid the corrugated effect of the dirt track. We shortly come to an open area on both sides of the road. To our left is "the old Rye Field" and to the right is the old Cornish Tavern.

55: CORNISH TAVERN

Unlike the modern car or bus, stages and their teams required regular rest stops. There were two stops on Sandwich Road—Ellisville and

Cornish's Tavern in the Pine Hills. The Cornish Tavern was built in 1792 by Josiah Cornish, who with his wife "Nabby" (Abigail Clark Cornish) maintained an inn and popular local meeting place for many years. Even after the Old Colony Railroad reached Plymouth in 1845, there was a need for horse-drawn coaches to make connections to outlying towns. The tavern's popularity is attested to by an 1889 anecdote from Plymouth author Abby Morton Diaz, who writing in the *New England Magazine* remembered good times at the tavern in the early nineteenth century:

> *"Was that the Cornish's where you had your parties?"*
> *"Yes; Cornish's Tavern, eight miles or so on the old stage road that goes from Boston through Plymouth down to the Cape. Nabby Cornish! She was simple, sort of unfacultied; never knew when to put her potatoes in the pot. The minute a visitor came in she would lay hold of her broom and give the room 'only jest a slick an' a promus.' Thanksgiving and Forefathers' we youngsters took the girls up there, sleighing. The girls used to begin on their white gowns and tuckers and necklaces a good while beforehand, not for a full-do, but to have something somewhere near ready in case of short notice; for better sure than sorry, and now and then a fellow would be uncertain as to going. I remember my sister Prudy got her white gown all ironed and spread out on the front chamber bed, for the fellow she was lotting on to ask her was one of the ebbtide sort, slower'n stock still, and always behind hand—but love will go where 'tis sent—! And after all he invited another girl. Poor Prudy! I can't help feeling sorry for her now. Well, she married a likely man, and—'tis all the same. They are all four gone! Up at Cornish's we just took that tavern and all that was in it, and rummaged and helped ourselves and turned things upside down. And we had a great supper, and we danced four-handed reels, and some did the double-shuffle, and we played plays. I presume you never played 'Oh, come, my Loving Pardner,' nor 'All the way to Boston,' nor 'Snip up.' And the singers used to sit around the great fireplace and sing:—'Madam, you shall have a coach and six, Six black horses black as pitch, If you'll be my true lover'—all the verses of it, and of—'There was a man who lived in the West, He loved his eldest daughter best, Bow ye down, bow ye down.'"*

After Josiah Cornish died, the inn was taken over by Isaiah and Benjamin Cornish, and then by Horatio Wright, a famous local sportsman's guide. "Forefathers'," mentioned above, refers to the old Plymouth holiday of Forefathers' Day (December 22). Forefathers' Day, the original Pilgrim holiday commemorating the landing on Plymouth Rock, was begun in 1769 by the members of the Old Colony Club in Plymouth and celebrated in many cities across America until a new association between the Pilgrims and Thanksgiving and the grudging acceptance of Christmas in New England in the 1830s

made it obsolete. It is still observed by the Old Colony Club, the Pilgrim Society and a few old Plymouth families.

After leaving the tavern, Old Sandwich Road continues on through the pines across Beaver Dam Road before it reaches Clam Pudding Pond, today part of the Pinehills development and not open to the public, but which has a number of traditions associated with it.

56: CLAM PUDDING POND

The traditional stopping point for travelers before Cornish Tavern was built was nearby Clam Pudding Pond. There, as the story goes, men on their way to the colony's legislative or General Court sessions would stop to take advantage of the pond's clear waters to drink and refresh their steeds, and eat "clam pudding," a local dish that could be carried in a leather bag or "wallet" and eaten cold on the journey. The pond was also the place where, according to Timothy Dwight and Dr. James Thacher, Plymoutheans would gather for an annual celebration, but they didn't say when or why this mysterious rustic event took place. Clam Pudding Pond's renown even resulted in earning it a place in local folklore as a spot in which witches gathered. In the mid-eighteenth century, a Mr. Wood of West Barnstable accused Liza Towerhill (Mrs. Elizabeth Blachford, 1712–1790) of putting a bridle and saddle on him at night and riding him many times to Clam Pudding Pond in Plymouth, where the witches had their coven meetings. Perhaps the Plymoutheans' annual celebrations became a witches' orgy in the fevered mind of Mr. Wood.

Old Sandwich Road can be followed through the woods for another few miles to where it comes out onto State Road (Route 3A) at Ellisville.

Our final stop is the largest in area—the Myles Standish State Forest. It can be accessed at several points, including the continuation of Billington Street after it passes the entrance to Morton Park at Billington Sea (see Tour 2), by Alden Road off Long Pond Road and by Cranberry Road off Federal Furnace Road in Carver. The reservation offices and facilities are at the southern end of the forest, at the end of Cranberry Road.

57: MYLES STANDISH RESERVATION
A Western Byway

The first state forest created in Massachusetts, Myles Standish Reservation was compounded out of the agriculturally valueless woodland south of town in 1916. Its leading feature is that it is one

Myles Standish State Forest. Park headquarters on the southern border of the Myles Standish Reservation, where campers can check in for information and campsite bookings.

of the East Coast's largest remaining examples of the unique pitch pine/scrub oak ecosystem known as "pine barrens." Much of the land south of Plymouth Center is or was pine barrens and of no use as farmland. In 1709, thirty thousand acres of this unprofitable sort were divided into ten "great lots" that were shared out among the two-hundred-odd proprietors, the heirs of the original "purchasers" who assumed the colony debt in 1628. It is largely "great lot" acreage that makes up the Myles Standish Reservation today.

Plymoutheans used the pine barrens as a place to hunt and fish, a source of firewood and, more recently, for building homes. Several massive private estates were carved out of the old woodlots in the late nineteenth century by men who first came here to enjoy rural sports and Plymouth's salubrious summer air. The three-thousand-acre Symington Estate has today become the Pine Hills development, with a planned 2,788 units. The project was planned as an open-space, mixed-used development as an alternative to the standard grid subdivisions that predominate the region, with over 70 percent of the land to be maintained as open space (including golf courses).

The Myles Standish Reservation ensures that a sizeable proportion of Plymouth's woodland will remain undeveloped. The nearly fifteen-thousand-acre forest has five camping areas, leased cabins and a fifteen-mile network of paved bicycle paths. The forest also has thirty-five

miles of equestrian trails and thirteen miles of hiking trails. The park's sixteen glacial "kettle ponds" are stocked with trout and draw fishermen throughout autumn, and in-season hunting is allowed, with two areas of the forest stocked with game birds in October and November. Wild turkeys, reintroduced in the 1970s, can be seen walking across the roads in a stately and unhurried manner. There are numerous cranberry bogs along its southern and eastern boundaries, although the best place to see the cranberry harvest is in the neighboring town of Carver. Campers may stay at any of the forest's 570 sites, which are available on a first-come, first-served basis, for a nightly fee. Most areas are equipped with hot showers, toilets, fireplaces and picnic tables. The campground office hours are 8:00 a.m. to 8:00 p.m. The regular camping season is from mid-April through mid-October.

Bibliography

Baker, James W. *Images of America Series: Plymouth*. Charleston, SC: Arcadia Publishing, 2002.

——. *Images of America Series: Plymouth Labor and Leisure*. Charleston, SC: Arcadia Publishing, 2005.

——. *Plimoth Plantation: Fifty Years of Living History*. Plymouth, MA: Plimoth Plantation, 1997.

——. *Plymouth Illustrated: 1893 - A Tour of Plymouth as it Was Long Ago*. Plymouth: Old Colony Club, 1993.

Baylies, Francis. *An Historical Memoir of the Colony of New Plymouth. Vol. 1—Part the First. From 1620 to 1641; Volume 2—Parts II, III, IV*. Boston: Hilliard, Gray, Little & Wilkins, 1830.

Davis, William T. *Ancient Landmarks of Plymouth: Part 1. Historical Sketch and Titles of Estates; Part 2. Genealogical Register of Plymouth Families*. Boston: A. Williams, 1883. Reprinted in a second enlarged and corrected edition. Boston: Damrell & Upham, 1899.

——. *History of the Town of Plymouth*. Philadelphia: J.W.Lewis, 1885.

——. *Memoirs of an Octogenarian*. Plymouth, MA: Memorial Press, 1906.

Kingman, Bradford. *Epitaphs From Burial Hill, Plymouth, Massachusetts, From 1657 to 1892*. Brookline, MA: New England Illustrated Historical Publishing Co., 1892.

Langdon, George D., Jr. *Pilgrim Colony: a History of New Plymouth, 1620–1691*. New Haven, CT: Yale University Press, 1966.

Philbrick, Nathaniel. *Mayflower: A Story of Courage, Community, and War*. New York: Viking, 2006.

Russell, William S. *Guide To Plymouth, and Recollections of the Pilgrims*. Boston: For the Author, 1846.

——. *Pilgrim Memorials and Guide for Visitors to Plymouth Village*. Boston: For the Author, 1851.

Stratton, Eugene. A. *Plymouth Colony: Its History and People, 1620–1691*. Salt Lake City: Ancestry Publishing, 1986.

Thacher, James. *History of the Town of Plymouth, from its First Settlement in 1620, to the Present Time, with a Concise History of the Aborigines of New England, and Their Wars with the English &c.* Boston: Marsh, Capen & Lyon, 1832.

de Tocqueville, Alexis. *Democracy in America.* Boston: Ticknor & Fields, 1862.

Torrey, Bradford, ed. *Writings of Henry David Thoreau, Journal.* Boston: Houghton, Mifflin, 1906.

Visit us at
www.historypress.net